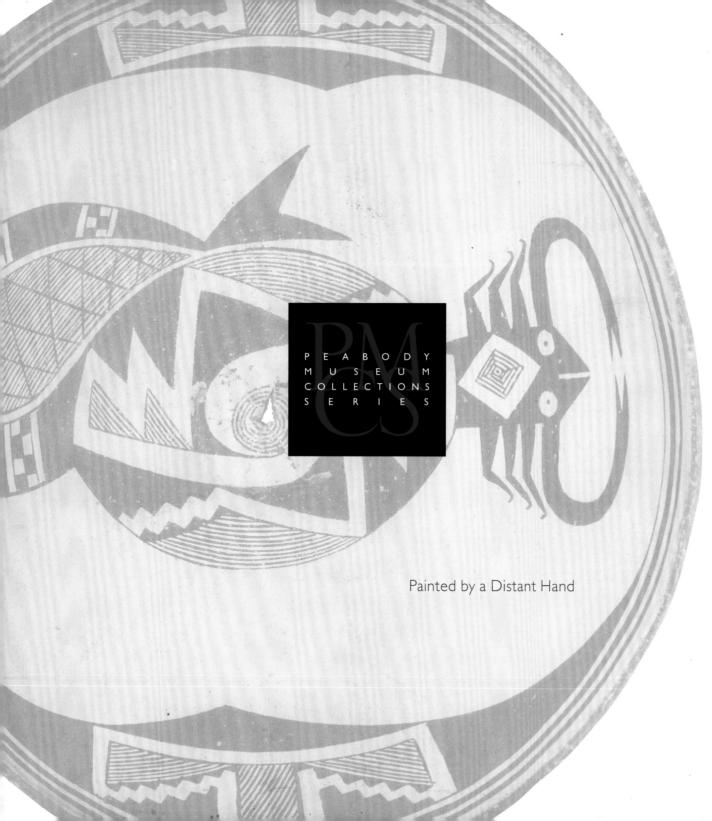

PEABODY
MUSEUM
COLLECTIONS
SERIES

Painted by a Distant Hand

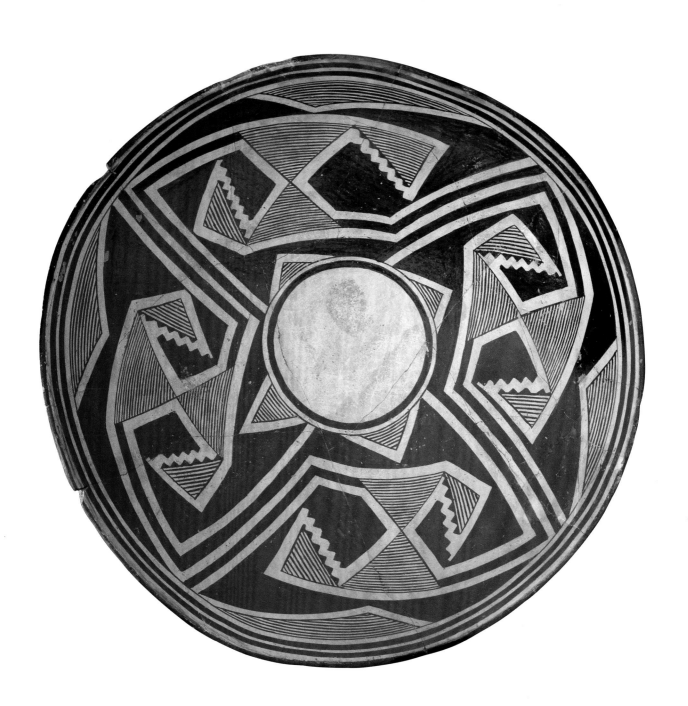

Painted by a Distant Hand

Mimbres Pottery from the American Southwest

Steven A. LeBlanc

Foreword by Rubie Watson

Photographs by Hillel S. Burger

Rubie Watson, Series Editor

Peabody Museum Press, Harvard University

Editorial direction by Joan K. O'Donnell
Copy editing by Jane Kepp
Cover and text design by Kristina Kachele
Composition by Donna Dickerson and Kristina Kachele
Color separations by iocolor, Seattle
Printed and bound in China by C&C Offset Printing Company, Ltd.

ISBN 0-87365-402-1

Library of Congress Cataloging-in-Publication Data:

LeBlanc, Steven A.
Painted by a distant hand : Mimbres pottery from the American Southwest / Steven A. LeBlanc ; foreword by Rubie Watson ; photographs by Hillel S. Burger.
p. cm.—(Peabody Museum collections series)
Includes bibliographical references.
ISBN 0-87365-402-1 (pbk. : alk. paper)
1. Swarts Ruin Site (N.M.) 2. Mimbres pottery—Themes, motives. 3. Mimbres pottery—Classification. 4. Mimbres culture—New Mexico—Mimbres River Valley. 5. Archaeological expeditions—New Mexico—Mimbres River Valley—History. 6. Mimbres River Valley (N.M.)—Antiquities. 7. Cosgrove, H. S. (Harriet Silliman), b. 1877—Archaeological collections. 8. Cosgrove, C. B. (Cornelius Burton), b. 1875—Archaeological collections. 9. Peabody Museum of Archaeology and Ethnology—Archaeological collections. I. Title. II. Series.

E99.M76L383 2004
738.3'09789'692—dc22
 2004014562

FRONTISPIECE: Mimbres Black-on-white bowl, Style III, geometric, 25-11-10/94787, Swarts Ruin, Mimbres Valley, New Mexico, A.D. 1000–1150. Rock-tempered ceramic with mineral paint, diameter 33.5 cm, height 12.5 cm. Peabody Museum, Harvard University, T4307.1. Hillel S. Burger, photographer.

Contents

Illustrations

PLATES

EXPLORING MUSEUM COLLECTIONS

Rubie Watson

By any estimation, Harvard's Peabody Museum of Archaeology and Ethnology maintains an extraordinary collection of artifacts. More than six million objects from the Americas, Oceania, Africa, Asia, the Middle East, and prehistoric Europe make the Peabody one of the largest and most comprehensive anthropology museums in the world. Peabody-sponsored excavations and expeditions are the source of many of these collections, and because they entered the museum accompanied by field notes, journals, maps, photographs, and site reports, their research value is enormous. As you will see from Steven LeBlanc's *Painted by a Distant Hand,* this rich documentation results in fascinating insights as generation after generation of researchers return to the collections with new questions and methodologies.

 Painted by a Distant Hand presents an enormously important collection of pottery from the Mimbres Valley in southwestern New Mexico. Most of the collection, which numbers over 700 items and documents a remarkable people and their culture, was excavated for the Peabody Museum in the 1920s by Harriet and Burton Cosgrove. With energy, boldness, and occasional bursts of wry humor, the Mimbres people created a style of painted pottery that has the capacity to fascinate, intrigue, and educate

us nearly a thousand years after it was made. Indeed, many of the figures that Mimbres artists painted on their ceramic bowls have become icons of Native North America and its art.

Some one hundred Mimbres bowls and jars were exhibited from 2003 until 2005 in a very successful Peabody exhibition, also titled *Painted by a Distant Hand.* Like most museums, the Peabody is able to exhibit only a fraction of its vast collections. Exhibitions tend to be short-lived, but the importance of the Mimbres collection and the overwhelmingly positive response to the exhibit left us in no doubt that the Mimbres collection deserved wider and more lasting attention. Hence, this publication.

Both exhibitions and books allow authors to share their research and passions, but they communicate information differently. Exhibitions are driven by the visual, and books by words. Dr. LeBlanc's volume on the Mimbres collection and the other books in the Peabody Museum Collections Series do both: They provide important data and interpretation, and they are richly visual. This book series aims to exhibit Peabody collections between two covers, producing accessible books that showcase the museum's important but rarely seen holdings.

Like its companion books in the series, *Painted by a Distant Hand* focuses on an extraordinary collection and provides archaeologists and non-archaeologists alike with an opportunity to share in an exercise in museum anthropology at its best. Using new methodologies and techniques, Dr. LeBlanc has given us a fascinating account not only of Mimbres culture and the art it inspired, but also of the way that archaeologists work as they transform artifacts into the building blocks of living history.

In this volume, Dr. LeBlanc, who has spent most of his career studying the history and prehistory of the American Southwest, puts forward a bold analysis. Thanks to the large amount of extant Mimbres pottery, and building on the insights of other archaeologists, he is able to discern the hand of individual painters of these pots—something that archaeologists working from often fragmentary artifacts are rarely able to do. This breakthrough makes it possible to think about innovation, creativity, and changes in art styles in new and exciting ways. We are grateful to Dr. LeBlanc for making it possible for us to enjoy and learn from a museum collection of great beauty and scholarly significance. I trust you will enjoy *Painted by a Distant Hand*—and the inspiring art of the Mimbres people—as much as I have.

ACKNOWLEDGMENTS

I would like to acknowledge foremost the invaluable help of Tony Berlant in developing many of the ideas presented here and in selecting the objects I have used. In addition, this book would not have been possible without the original vision of Rubie Watson for a series on the Peabody Museum's collections and the enthusiastic support of William Fash, director of the Peabody Museum. It was members of the museum staff who made the volume a reality, especially Steve Burger, who took all the photographs. Tori Cranner, Jennifer Mimno, Julie Brown, and Pat Kervick were key in working with the artifacts and photographs, and Bob Ganong created the reproduction of Swarts Ruin. Many other members of the Peabody Museum staff also contributed in numerous ways. Sam Tager provided critical opinions and ideas for the exhibit that this volume follows. The suggestions of two anonymous reviewers were also useful and appreciated. The book saw the light of day through the patient efforts and oversight of Joan O'Donnell, along with Jane Kepp (copy editor), Tina Kachele (designer), Carol Cooperrider (cartographer), and especially Donna Dickerson, whom I thank for all her support and assistance.

Painted by a Distant Hand

THE BEGINNINGS
OF A COLLECTION

Whimsical, endearing, unexpected, sophisticated—no other pottery tradition in the Americas seems to capture the fancy of so many different people in so many different ways as Mimbres painted bowls. Discovered long after Euro-Americans had stumbled upon the Mesa Verde cliff dwellings and the great towns of Chaco Canyon, the pottery of the Mimbres people is associated with no magnificent multistoried pueblos or spectacular scenery. Instead, it was made in a gentle valley traversed by a small river, home to a few thousand people about ten centuries ago. For several hundred years these Mimbreños produced a unique painted pottery. Then the painting tradition, like the people, seemingly vanished from history.

Some ancient pottery can simply be looked at and admired. But Mimbres bowls, because of the remarkable intricacy of their geometric designs, the appeal of the animals some of them portray, and the enigma of the stories apparently represented on others, evoke persistent questions about who made them and why. Though their

The Peabody Museum's Mimbres Expedition flag being flown at the field camp at Swarts Ruin in the mid-1920s. Peabody Museum, Harvard University, photo N36418.

3

The Mimbres region in the greater Southwest. Map by Carol Cooperrider.

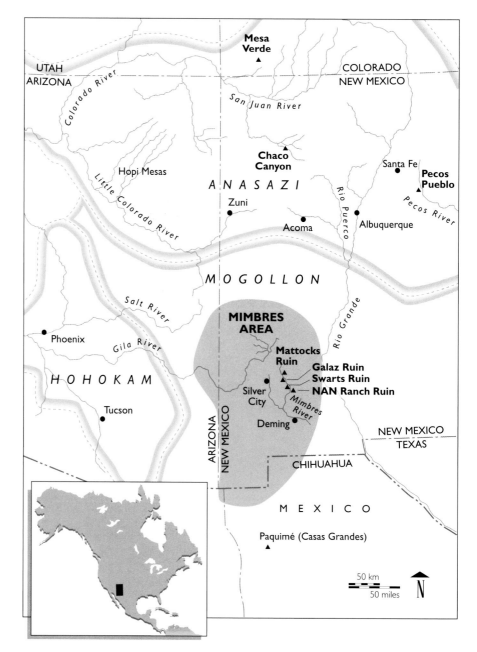

riddles are far from solved, researchers have learned much about their makers in the last few decades and have gained new insights into the ceramic tradition.

The Mimbres River of southwestern New Mexico derives its name from the Spanish term *mimbre,* for a small willow tree that grows along its banks. Less than one hundred miles long, rarely more than ten feet across and a couple of feet deep, the river flows from the mountains out onto the desert plain, where it sinks underground. From A.D. 200 to 1150, generations of farmers lived along its banks. Today we call them the Mimbres people or culture, after the river. When Spanish settlers reached the valley in the early 1700s, it was home to a band of Apaches who had only recently migrated there. All knowledge of the ancient Mimbres had long been lost.

Our story really begins about a hundred years ago, when E. D. Osborne, a farmer and rancher who lived at the lower end of the Mimbres River near the New Mexico town of Deming, dug up some pottery and sent photographs of it to J. Walter Fewkes of the Smithsonian Institution.[1] A few pioneering archaeologists, such as Henry

Henshaw and Clement Webster in the 1880s and 1890s and Nels Nelson and Francis Duff in the first decade of the 1900s, had previously done quick, site-finding surveys and even some limited excavations in southwestern New Mexico. But the absence of standing sandstone-block masonry pueblos and picturesque mesas and buttes soon quelled their interest, and most of them went back to northern New Mexico and Arizona to work. Osborne's painted bowls—depicting animals and people and even seeming to tell stories—were therefore a revelation to Fewkes, who had excavated Hohokam sites near Phoenix, Arizona, and Anasazi sites near Zuni, New Mexico, and at the Hopi mesas in Arizona.[2]

Between 1914 and 1923 Fewkes purchased for the Smithsonian the bowls Osborne had excavated and spent a little time excavating more bowls from sites in the valley. A series of digs at several sites by other archaeologists soon followed.[3] These were at best poorly reported in somewhat obscure publications. By the early 1920s, local ranchers and townspeople, too, had become intrigued by the pottery. Looting, both for profit and for personal collections, was becoming increasingly common. It was at this juncture that the then "dean" of Southwestern archaeology, A. V. Kidder, took an interest in the region through a local couple—Hattie and Burt Cosgrove.

The story of Harriet (Hattie) and Burton (Burt) Cosgrove has been wonderfully told by Carolyn O'Bagy Davis in her book *Treasured Earth*. The couple lived in Silver City, New Mexico, where Burt worked in the hardware business. They became fascinated with the Mimbres culture, but unlike so many others, they were determined to learn how to do archaeology correctly and not just go digging for pots. They visited many of the early field projects in the Southwest and developed a friendship with Kidder, who was associated with the Peabody Museum at Harvard. Kidder was so impressed with their abilities that he arranged for them to join the Peabody staff and direct a Peabody expedition. Burt quit his job at the hardware store, and with Kidder's encouragement and support, the couple excavated Swarts Ruin in the Mimbres Valley from 1924 to 1927. Although known locally for many years, Swarts Ruin had suffered only minimal looting and so held the promise of revealing an entire Mimbres community.

Later, from 1928 to 1930, Hattie and Burt Cosgrove worked to salvage what they could from the many looted caves in the mountains in the Mimbres area.[4] They also

purchased the Mimbres site called Treasure Hill, not far from Silver City, in order to preserve it. The Cosgroves' association with the Peabody Museum endured for many years; they resided in Cambridge, Massachusetts, in the winters and spent summers in the field in the Southwest. They worked with Kidder on Pendleton Ruin in the boot heel of New Mexico in 1933, and in the mid- to late 1930s, after Burt's death, Hattie went on to work with the museum on excavations at the site of Awatovi on Antelope Mesa on the Hopi reservation. There she played an important role not only in studying the pottery but also in leading the social life of the camp.[5]

The focus of the Peabody expedition was Swarts Ruin, named after the Swarts Ranch, where it was located, although limited work was done at other sites as well— especially NAN Ranch Ruin, across the river, and some caves in the nearby mountains. The village originally consisted of three blocks of some fifty to sixty rooms each, which

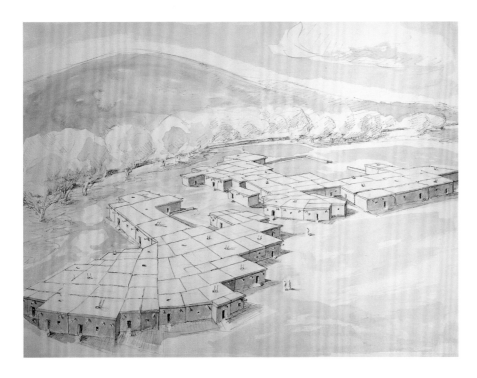

Artist's reconstruction of Swarts Ruin around A.D. 1100, with the Mimbres River in the background. Painting by Bob Ganong. T4222.1. Copyright Peabody Museum, Harvard University.

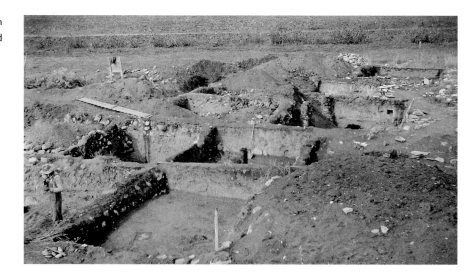

Excavation of rooms at Swarts Ruin under the supervision of Hattie and Burt Cosgrove in the 1920s. Peabody Museum, Harvard University, photo N13380.

overlay a dozen earlier pithouses. One part of the site had been badly damaged by looters, so the Cosgroves concentrated on excavating the two remaining roomblocks. They spent their three field seasons at Swarts digging more than 150 rooms and pit-houses. Thousands of potsherds, pieces of chipped stone, corn-grinding tools (manos and metates), axes, hoes, and other instruments of daily life were uncovered.

But the focal point of the Cosgroves' report on their findings, *The Swarts Ruin: A Typical Mimbres Site in Southwestern New Mexico* (1932 [2004]), and of the public's fascination with the site was the more than seven hundred painted pottery vessels found. Most of these came from burials beneath the floors of rooms, in abandoned structures, and in open spaces between and around the roomblocks. Hattie Cosgrove painstakingly restored the painted bowls and executed all the bowl drawings that appeared in the final report; some of her drawings are shown here on pages 27 and 80.

The Cosgroves' report, which presented the entire corpus of painted bowls that had been excavated, was a remarkable achievement for its day, even had it been written by professional, university-trained archaeologists. That it was produced by semiretired local tradespeople makes it even more extraordinary. It was the most complete and detailed publication at the time on the Mimbres people. For more than seventy-five

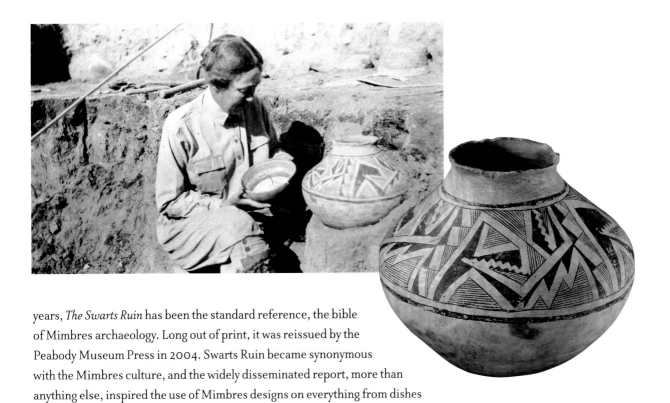

years, *The Swarts Ruin* has been the standard reference, the bible of Mimbres archaeology. Long out of print, it was reissued by the Peabody Museum Press in 2004. Swarts Ruin became synonymous with the Mimbres culture, and the widely disseminated report, more than anything else, inspired the use of Mimbres designs on everything from dishes in Santa Fe Railroad dining cars to the works of modern Pueblo potters.

It is the artifacts from Swarts Ruin that form the bulk of the Peabody Museum's Mimbres collections, and nearly all the pottery depicted in this book is from Swarts. Artifacts from the other sites excavated by the Cosgroves as part of their expedition are also housed at the Peabody, along with a very few Mimbres items from other sources.

A large Mimbres Black-on-white water jar, Style III, geometric, from Swarts Ruin. PM 24-15 10/94549, 27.5 cm x 37 cm. T4306.1. Hillel S. Burger, photographer. Above left, Hattie Cosgrove poses with the same jar, which she has just excavated. Peabody Museum, Harvard University, photo N36419.

A Brief History of the Mimbres People

The story of the Mimbreños has been told many times, so I summarize it here only briefly.[6] Some archaeologists believe that sometime between 2000 and 1000 B.C., corn-raising farmers migrated into what is now the American Southwest northward from present-day Mexico. Others think the Southwest was already occupied by foragers of wild plants and animals who obtained cultigens and became farmers around this time, and that no migration of people took place. In either case, the earliest farmers lived in small villages of circular, slightly subterranean pithouses, with large storage pits for their corn harvests. They did not make pottery. Early farming sites of this sort have been found within a hundred miles east, west, and south of the Mimbres area but have yet to be clearly detected in the Mimbres Valley itself.

Sites dating to around A.D. 200, however, are found in the valley. Almost always situated on the tops of hills or ridges, these villages encompassed substantial pithouses. Some had as many as eighty structures, although they were not necessarily all contemporaneous. Judging from their architecture and pottery, the inhabitants of these

pithouse villages seem to have been the direct ancestors of the Mimbres people. They raised corn and made pottery: plain brown globular jars and small bowls.[7]

Around A.D. 550 the people abandoned the hilltops and established new villages along the Mimbres River, just above its floodplain. They and their descendants lived in these villages for the next six hundred years. Over those centuries, they built, rebuilt, abandoned, filled in, or dismantled individual pithouses and built newer structures on top. Swarts Ruin was one such village, although it was not founded until around A.D. 750.

By 1100, some seventeen villages roughly the size of Swarts Ruin lay along the Mimbres River and its major tributaries, each about three miles from the next. Swarts Ruin was one of these. A handful of other large sites was set along the Gila River and near the Rio Grande. In addition, dozens of smaller villages and farmsteads were situated in upland areas and along minor drainages.

Initially, the large river-edge villages consisted of pithouses spaced a few yards apart from one another, usually with one extra-large pithouse that was used as a communal or ceremonial precinct. Early pithouses were circular in plan, but they evolved into rectangular structures dug three to four feet into the ground, with the roof above ground level and a ramped entryway by which people came and went.

Around A.D. 950 or 1000—that is, within a short transitional period—these semi-subterranean structures were replaced by above-ground rooms with walls made from river cobbles set in adobe mud. They had flat roofs supported by posts inside the rooms; the roofs were covered with brush, grass, or bark and then plastered over with adobe. Rooms were linked into roomblocks, and as the population increased, new rooms were added. At their peak, around 1100, the two excavated roomblocks at Swarts Ruin had 120 rooms.

The years between A.D. 1000 and 1150, which coincided with the florescence of the painted pottery tradition, are often referred to as the Classic Mimbres period. In the 1920s there was no accurate way to date the ruins, and Hattie and Burt Cosgrove, like all the other archaeologists working in the Southwest, assumed that the Mimbres culture was roughly contemporaneous with the cliff dwellings of Mesa Verde. With the development of tree-ring dating in the late 1920s and 1930s, the dates of the major

cultures of the Southwest, such as those of Mesa Verde and Chaco Canyon, were worked out. But tree-ring dating requires pieces of either preserved wood or wood charcoal. In the 1920s it was believed that nothing could be learned from small pieces of charcoal, and the excavators of Mimbres sites had not saved them. Consequently, even after the development of tree-ring dating, the previously excavated Mimbres sites, including Swarts Ruin, could not be dated—one cautionary tale among many about the value of curating material from excavations that has little present use but might be important in the future.

Sadly, the looting that the Cosgroves observed in the 1920s only intensified. Fifty years later, all but a handful of Mimbres sites had been severely damaged or completely obliterated by looters looking for bowls. This state of affairs led to attempts to salvage what information remained about the Mimbres with new excavations. From this new wave of excavations, beginning in the 1970s, came new wood and charcoal samples, and dates for the Classic Mimbres culture at last could be determined. The very first season of work at Mattocks Ruin in 1974, one of the first of the new excavations, produced tree-ring dates from rooms that appeared to have been used at or near the end of the site's occupation. Their dates were expected to fall near the end of the Mimbres Classic, which was then considered to have been the mid-1200s. Instead, the dates turned out to be in the early 1100s, more than a hundred years earlier than expected— forcing archaeologists to rethink the time frame for the Mimbres.[8]

In hindsight the dates are not surprising. Almost thirty years later we have tree-ring dates for eighteen Mimbres sites, and it is now abundantly clear that the Mimbres culture either ceased to exist or underwent a radical change—depending on one's perspective—sometime between 1130 and 1150. This was just at the time the Chaco culture collapsed in the north and the Hohokam culture of the Tucson-Phoenix basin, too, was radically transformed. We can surmise that some series of events was affecting the entire Southwest at this time, a topic I return to later.

We have, then, a sequence of mostly gradual changes in Mimbres architecture and pottery that commenced at around A.D. 200 and continued essentially unbroken for nine hundred years. Researchers have some ideas why most of these gradual changes occurred. For example, the shift from pithouses to attached, above-ground rooms

MIMBRES ARCHAEOLOGICAL PERIODS

Date A.D.	Period	Key Features
	Post-Mimbres	Depopulation; different architectural style; no more Mimbres pottery
1150		
	Classic	River-edge villages; above-ground rooms combined into roomblocks; florescence of painted pottery
1000		
	Late Pithouse	River-edge villages; semi-subterranean pithouses; painted pottery
500		
	Early Pithouse	Hilltop locations; semi-subterranean pithouses; plain pottery
200		
	Archaic	Little occupation; no pottery

might reflect an increase in the size of the basic corporate group—that is, a suite of rooms was better suited for a closely integrated extended family than were separated pithouses. Yet two issues remain unresolved. The first concerns the shift from nearly all sites to none at all being situated on hilltops, which marked the transition from the Early Pithouse to the Late Pithouse period, and the shift from pithouses to above-ground structures, which marked the beginning of the Classic period. Each shift must have taken less than a generation to effect, but why these changes were so rapid and dramatic remains a mystery. The second and even greater mystery is why the Mimbres sequence ended so abruptly.

The Cosgroves did not know that population and environment had changed during the Mimbres sequence. Since the 1970s, scholars from a variety of institutions have fleshed out much of the regional population dynamics and have provided a new, though still provisional, understanding of the regional ecology. This new knowledge resulted from a different way of doing archaeology. In the 1920s, the approach was to look somewhat randomly for sites, and when an interesting one was found, it might be excavated. Beginning around the 1970s, archaeologists began to take a new approach. Teams of archaeologists, each person spaced a few dozen yards from the next, now systematically walked large tracts of land with the goal of finding and recording every site in the tract. In this way the size, time period, and environmental setting of each site could be determined. Researchers began to learn not only where sites were but also where they were not.

By sampling a large area such as the Mimbres Valley, just as pollsters sample an entire state or country, one can extrapolate from the sample and estimate the numbers, sizes, and time periods of sites in an entire region. This allows researchers to look at population growth and decline over time and to see how different environments were being used at different times. With this sort of information, which was unavailable to the Cosgroves and their contemporaries, archaeologists now see that the population of the Mimbres Valley grew about tenfold from A.D. 200 to a peak around 1100. This peak was followed quickly by a substantial decline in numbers.

Similar site survey work, initially done just in the Mimbres Valley, has been extended throughout southwestern New Mexico. Archaeologists interpret the information it has produced differently. Using it, some workers estimate a maximum population of a few thousand—perhaps as many as five thousand—Mimbres people for all of southwestern New Mexico; others cut the estimate to perhaps a third of that. I believe the larger number is better supported by all the lines of evidence together, but in any case, the numbers of Mimbres people alive at any one time were modest.[9]

How are the Mimbres people related to the modern indigenous peoples of the Southwest? The question remains unanswered. Archaeologists divide the prehistoric societies of the region into three broad groups: Anasazi, Mogollon, and Hohokam. The Anasazi, who lived in the northern part of the Southwest, a region dominated by

picturesque sandstone mesas, were ancestral to today's Pueblo peoples, who include the Hopis, Zunis, Acomas, and Rio Grande Pueblos. The Hohokam, who lived in the low desert in the vicinity of modern-day Phoenix and Tucson, may have been ancestral in part to the contemporary Pimas and Tohono O'odham (Papagos). The mountain and valley territory between the Anasazi and Hohokam areas was occupied by a culture that archaeologists call Mogollon. There were numerous societies in this rugged region, of which the Mimbres was one and probably the largest.

To date, archaeologists have been unable to show any clear links between the Mogollon, including the Mimbres, and either the modern Pueblos or the Pima–Tohono O'odham. There is a general relationship among them, of course, and all these peoples share many cultural traits. But the Pueblo peoples today speak several different languages, including four that are completely unrelated. Did the Mogollon speak one of these? Did the Mogollon-Mimbres population dwindle and small numbers of survivors merge with each of several Pueblo peoples? Might a substantial number of survivors have helped form one of the Pueblo groups, so that their language is spoken by that group today? Or did the Mogollon-Mimbres people disperse and some become the Tarahumaras or other groups in northern Mexico? For the most part these questions remain unanswered. The most obvious candidate for a Pueblo community with a significant degree of Mogollon ancestry is Zuni, judging from the pueblo's geographic proximity to the Mogollon area and some shared material culture traits. Although the possible links are tantalizing, they are still quite tenuous, and it will require additional research to resolve this fascinating question.

MIMBRES DAILY LIFE

Hattie and Burt Cosgrove were interested in the typical Mimbres lifestyle, and despite the development of other research issues over the years—such as regional population dynamics and the nature of long-distance trade—the question of just how the Mimbres lived still draws archaeologists' attention. The problem, of course, is determining what is typical. Is New York City typical of the United States, or is a suburb of Cincinnati more typical? Despite the oversimplification inherent in such an exercise, I will try to describe the "typical" Mimbres lifestyle.

The Mimbres people were farmers, cultivating crops on the floodplains of the Mimbres River and its major tributaries. In their valley they grew corn, beans, and squash, all first domesticated in Mexico. At lower elevations they grew cotton. In some places archaeologists have found the remains of irrigation systems. These were probably in use all along the river, but modern farming has obliterated their traces or reused the ancient canals. In small watersheds in the upper reaches of the valley, farmers terraced their fields with low linear walls to slow runoff and retain enough

moisture to farm the terraces. Traces of these low "check dams" remain visible in the hills above the river, providing evidence of both the ingenuity of the Mimbreños and their need for additional farmland. Although farming probably supplied the majority of calories by Classic times, collecting wild plants and hunting were also important.

A good deal of information about Mimbres lifeways can be gleaned from the paintings on pottery. Mimbres bowls show people setting snares for birds, using long nets for communal jackrabbit drives, and hunting bear or returning from the hunt with deer, pronghorn antelope (pl. 5), or turkeys. Some birds were probably taken for their plumage, which was used in ceremonies, and people throughout the Southwest also made turkey-feather blankets.

Not much in the way of clothing is shown on the bowls. People are occasionally depicted wearing sandals, and indeed the Cosgroves found in dry caves dozens of sandals made from yucca fiber in sizes to fit both adults and children. Women wore an apronlike garment made up of many strands of cord attached to a small woven section five or six inches wide. This garment was held in place by a fiber or woven belt that tied in front. The belt held the woven section pressed against the abdomen. The strands attached to the woven endpiece hung down in front of the body, were passed between the legs, and then were pulled inside the belt at the back. The ends of the strands draped over the belt in the back and fell twelve inches or so behind the wearer's legs. When Mimbres women are depicted in profile on bowls, they almost always wear such garments, shown with the strands of the end of the apron hanging down behind them. The two women sitting beside a blanket on the bowl shown in plate 12 are wearing such aprons. On the bowl at right, a belt and the long strands of cord of the apron have been removed and are lying beside a woman while she gives birth. Aprons of this sort have been found in dry caves in the Mimbres area and throughout the Southwest.

Mimbres Black-on-white bowl, Style III, depicting a woman giving birth. Swarts Ruin, PM 24-15-10/ 94632, 17 × 5.5 cm. T4309.1. Hillel S. Burger, photographer.

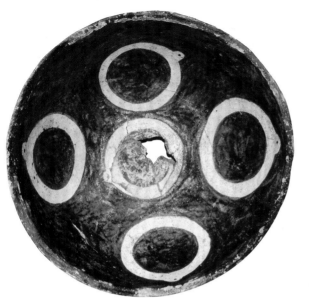
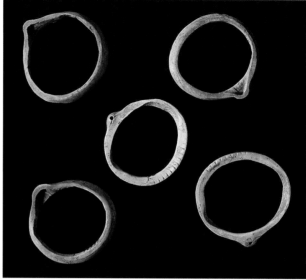

This Mimbres Black-on-white bowl, Style III, depicts bracelets like those shown at right. Swarts Ruin, PM 24-15-10/94692, 16.5 x 6 cm. The bracelets, made from *Glycymeris* clam shells from the Gulf of California, were also found at Swarts Ruin. PM 25-11-10/95301A–E. Left, T4226; right, T4244.1. Hillel S. Burger, photographer.

Shell bracelets, necklaces, and woven leggings (pl. 9) are also depicted on Mimbres bowls, and archaeological examples of all of these items have been found. Mimbres men wore some type of sash or loincloth (pl. 12), but no archaeological remains that can be identified as such have been discovered. Interestingly, people are not shown on painted bowls wrapped in blankets or other cold-weather clothing. As I discuss later, Mimbres drawing conventions might have precluded such depictions.

Almost two decades of work undertaken in the 1970s and 1980s at NAN Ranch Ruin, a site near Swarts Ruin, helped clarify the internal structure of a Mimbres village. The Cosgroves had focused primarily on rooms at the Swarts site, but workers at NAN Ranch Ruin devoted a great deal of energy to excavating outdoor areas. Many daily activities, such as grinding corn and cooking, took place outside. A plaza area between the roomblocks at the NAN site may have been used for public ceremonies—perhaps dances—an inference based on the discovery of apparent dedicatory offerings buried in it. In their limited excavations away from rooms at the Swarts site, the

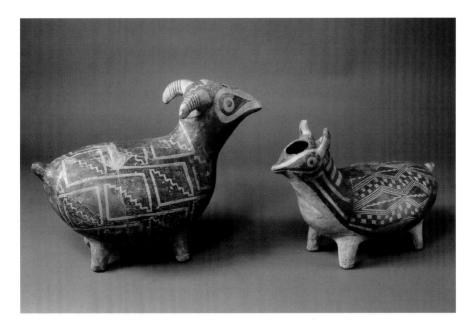

These two effigy jars were found near each other at Swarts Ruin and were probably made by the same person. Left, bighorn sheep, PM 25-11-10/94933, 19.5 × 29 × 14 cm; right, pronghorn, PM 25-11-10/94932, 24 × 35 × 16 cm. T4281.1. Hillel S. Burger, photographer.

Cosgroves, too, found several such dedicatory offerings in its plaza, including a pair of animal effigies representing a bighorn sheep and a pronghorn. They also uncovered some evidence for both domestic and ceremonial use of the spaces between and around roomblocks. At NAN and probably at Swarts, people (perhaps those of low status, as discussed later) were sometimes buried outside of rooms in these more public spaces.[10]

The Mimbres made special rooms or structures for public or ceremonial activities even in their earliest villages. At first, a village might have had an extra-large pithouse, which probably served both as one family's home and as a place for ceremonies. Over time, pithouses were constructed for special functions. These were substantially larger than domestic houses and were not used for daily living. Initially circular, in time these ceremonial structures became rectangular and quite substantial in size. The largest one excavated to date, at Galaz Ruin, measured over eighteen hundred square feet.[11] These structures are often called "great kivas" because of

their similarity to ceremonial chambers that were used by the Anasazi and smaller versions still used by Pueblo people today. Their clear ceremonial function makes this analogy reasonable. The Cosgroves never excavated a great kiva at Swarts Ruin.

The Mimbres buried their dead beneath the floors of their rooms, in the fill of abandoned structures, and in the plaza areas around roomblocks. None of these locations was random. It appears that certain rooms held special significance and many burials took place in them. Among the Hopis today, each clan considers one household to have a room that is the clan's spiritual locus. Possibly a similar view prevailed among the Mimbres, and it was these rooms that received many burials—although interring the dead beneath room floors is not a Pueblo practice today. Abandoned ceremonial or public structures were also preferred places for burials. In each of these types of locations, it seems that the link with the past was important. Some scholars have proposed that the link was more than with the past; it was a link to an underworld where people originated or where the dead returned. But this is simply speculation.

About two-thirds of all burials during the Classic period included a painted bowl. Usually, but not always, the bowl had a hole punched in its bottom, a feature often colloquially referred to nowadays as a "kill hole" (see, for example, pl. 4). Many people have speculated on the meaning of the kill hole, but any interpretation is confounded by the evolution of Mimbres funeral practices over time. Before the Classic period, bowls (without kill holes) were usually broken and the pieces scattered in the burial pit. Later, just the hole was made, and the bowl was buried otherwise intact. Breaking the bowl might have been to release the bowl's spirit, whereas—drawing on ethnographic analogy—making the hole might have been to let the spirit of the deceased pass through the bowl. Possible explanations abound, but we really have no way of knowing what the intent was.

Rarely, multiple bowls were buried with a single person, and occasionally shell bracelets, turquoise and stone beads and pendants, and other objects were put into the grave. Perishable materials such as blankets, baskets, and wooden objects undoubtedly were common, but little of them remains. The Mimbres differed little from their contemporaries in the Southwest in the general types and numbers of

funerary objects they used, although groups varied in details such as where objects were placed and precisely what types of ceramics and other things were buried with the dead.

On the basis of information from NAN Ranch Ruin, archaeologist Harry Shafer suggested that plazas were considered a different kind of space from other burial locations. Plazas were the sites of cremations, never a common Mimbres custom but a rite used for a small number of the deceased. Moreover, a disproportionate number of young adult men were buried in plazas without burial bowls. Shafer hypothesized that Mimbres society was matrilocal—that women lived in the rooms of their mothers, and husbands moved from their natal homes to those of their wives. This is the common pattern among Pueblo people today. Shafer suspects that young men would have held little status in their new families. Not until they had several children and were better established would their social roles become stronger. Perhaps it was not until then that they would be buried, beneath the floor of a room, with a painted bowl.[12]

MIMBRES PAINTED POTTERY

The ancient Mimbres people are renowned throughout the world today for their painted bowls. Their admirers want to know, Why was this pottery so distinctive from the rest of Southwestern pottery? What do its figurative images mean? Who painted it? And why did its production cease so abruptly? It has been almost a century since the first bowls were excavated, and almost seventy years since the dig at Swarts Ruin gave us such a large corpus to work with, yet these questions remain largely unanswered.

From a technical perspective, Mimbres pottery was little different from, and indeed somewhat inferior to, contemporaneous pottery traditions in the Southwest. Bowls, and rarer jars and effigy vessels, were made by rolling out clay "ropes" and coiling them to form the vessel; the sides were scraped and sometimes polished smooth. Mimbres artisans, like their Southwestern contemporaries, did not use potter's wheels. Conforming to the usual Southwestern pattern, Mimbres painted bowls were simple hemispheres, though occasionally the hemispherical shape appears to have

been deliberately warped before the clay dried. If anything, Mimbres potters made their bowls less carefully than did their neighbors, with slightly thicker walls and less meticulous smoothing.

A slip of very fine clay that fired white was applied to the interiors of the bowls. Potters combined an organic material with finely ground hematite (iron oxide) to produce a paint. Modern Pueblo painters take a piece of yucca leaf, strip it, and chew it until it is pliable; then they cover the end of this "brush" with paint and drag it over a bowl's surface to paint a design. This is done with a pulling motion, not the brushing motion of a modern camel-hair brush painter. Although no such brushes have been found at Mimbres sites, the way lines are formed and the way they end on Mimbres vessels suggest that these artists used similar yucca brushes.

Vessels presumably were formed, left to dry, painted, then left to dry some more, as Pueblo pottery was made historically and is still made today. When several pots were ready, they would have been fired in a makeshift kiln on the ground surface or in a shallow pit. (No Mimbres kilns have been discovered.) When oxygen flow to the kiln was restricted—that is, when a reducing atmosphere was created in the kiln—the iron in the paint remained black. When oxygen penetrated the kiln to reach the bowl—an oxidizing atmosphere—the paint turned red (pl. 8). In other parts of the Southwest where a similar technology was employed, potters were capable of making the pottery always turn out black, but the Mimbres produced a mix of black- and red-painted bowls. On some bowls the paint color grades from black to red, showing that oxygen penetrated the kiln only partly (pl. 25). Because other Southwestern potters were so capable of maintaining firing atmospheres in which the paint fired only black, it seems that the Mimbres were deliberately letting oxygen get to their pottery. They must have liked the variety of color this lack of consistency in the firing atmosphere produced.

How were Mimbres pots used in daily life? Most people think of Mimbres bowls in terms of relatively complete examples found with burials, each with a "kill hole" in the bottom, but these represent only a portion of the bowls that were made.[13] Most Mimbres bowls were used in everyday life and eventually were broken accidentally, so that they are found only as small pieces, or potsherds. Estimates have been made of the total numbers of bowls that were made and broken on some Mimbres sites.

Researchers estimate the number of sherds on the site as a whole and then calculate the number of bowls they would make if put back together. This process reveals that people at sites such as Swarts Ruin must have used and broken about four thousand bowls during the life of the village.

But because the village was probably occupied for several centuries by perhaps a hundred people at any one time, it is more interesting to think in terms of the number of bowls adults might have owned during their life spans. Doing the math, it turns out that each adult probably owned only about eight bowls in his or her lifetime. Still, this is more bowls than a person would have needed for ceremonial use alone, so bowls most likely were used for serving food as well. Whether painted bowls were used for daily food service or only on special occasions is unknown. Some bowls show evidence of wear and tear and were surely used a great deal; others show minimal evidence of use for food service. Continued research should be able to enlighten us on this topic.

The Mimbres people made pottery other than painted bowls, too. They made large painted jars with small openings, like the one illustrated on page 9, that probably were used to carry and store water. Rarely employed as funerary goods, these vessels were used until they broke, and archaeologists seldom find intact examples of them. Smaller jars, including a special type called a seed jar, were preserved more frequently, but at Swarts Ruin only a few were found relatively intact. Judging from sherds, which are easily differentiated as having come from bowls or from jars, the Mimbreños produced perhaps five to ten times as many bowls as jars. Very occasionally they also made effigy vessels. The most famous of these are the pair from Swarts Ruin shown on page 19. Quite similar and found near each other, they likely were made by the same person and used for similar purposes.

The Mimbres people also made considerable use of unpainted pottery, which is often referred to as utility ware. Sometimes the narrow coils of clay used to form the vessels were left unsmoothed, creating what is termed corrugated or clapboard-corrugated decoration. This usually appears only on the upper halves of jars, and rarely on bowls. At least some of the utility jars were used as cooking pots, probably holding a stew or mush made of corn, beans, dried squash, and pieces of meat. Residues on the bottoms of these pots indicate that their contents were left to sim-

mer on the fire. We still do not know if the painted pottery was intended for everyday use or if the utility ware was more like today's plastic dishes and the painted pottery like fine china—taken out only on special occasions.

A surprising amount of the painted pottery was exchanged between villages. Researchers have been able to determine this by using two methods to study the constituents of the ceramics: thin-section analysis of the temper used in the pottery—that is, bits of crushed rock or sand that was added to the clay to prevent it from cracking as it dried—and neutron activation analysis (NAA), which determines the proportions of chemical elements such as strontium present in the clay body itself. Studies of temper have shown that either utility jars or the temper for them was traded extensively in the lower end of the Mimbres Valley, where the Swarts village was located. It is possible that traders carried temper over fairly long distances; one man could have carried enough in a single trip for about two dozen large jars.[14] Clay is a different matter. Without draft animals, transporting heavy clay more than a mile or two seems unlikely, so by studying the clay itself we can get an idea where the vessels were made.[15]

In recent years, sherd samples from at least twenty archaeological sites spanning the Mimbres area have been submitted for NAA by different researchers.[16] After receiving the results, they sorted the sherds into groups based on similarities between their constituents and thus were able to define about half a dozen kinds of clay that were being used. But this alone does not tell us where the clay came from. One way to solve this problem is to find a clay source, determine its element content, and match it to the pottery found at various sites. It is difficult, however, to find, in an entire region, the precise clay sources that might have been used. An alternative approach is to assume that most of the pottery used on a site was made there or not far away. Although a considerable number of pots could have been exchanged between sites, most of the utility vessels and large jars were presumably local products. By taking a large sample of sherds from a site and determining which clay type was most common there, we can surmise that this particular clay source was nearby even if we do not know exactly where it was located.

Mimbres bowl designs evolved over time, and by now archaeologists have pretty well worked out the design sequence. (This was not the case in the Cosgroves' time.) The

Mimbres first began to decorate pottery around A.D. 600, when they simply slipped vessels with red clay and then burnished the surface with a stone. This development was followed by the earliest painting of bowls, but designs were limited to a few straight lines applied in red paint on the plain brown clay background of a bowl's interior. Later, potters began to apply a cream slip to the interiors of bowls. These painting styles were in use prior to the founding of the Swarts community and are not represented in its collections, except by a few sherds that probably came from heirloom vessels. Swarts Ruin seems to have been founded about the time the Mimbres changed their pottery firing atmospheres from oxidizing to reducing. This change, which resulted in a black paint color on a whiter background, took place around A.D. 750.

By that time, designs had become often curvilinear, and use of a wavy line to form scrolls was common (opposite, *a*). Designs extended to the rim of the bowl, and there were no rim bands—concentric lines running around the bowl just below the rim. Later, rectangular elements were drawn and filled in—hachured—with wavy lines (opposite, *b*, and pl. 1). These styles are now often lumped together and referred to as Mimbres Style I, although the Cosgroves called them Boldface Black-on-white. Around A.D. 850 or 875, painters began to make the hachures with straight lines and painted the lines forming the edges of the hachured figures much wider than the hachure lines (opposite, *c*).

Subsequently, the designs stopped going to the rim, and a narrow blank space was left just below the rim (opposite, *d*). These attributes are now considered hallmarks of Mimbres Style II; the Cosgroves included this style in their Boldface Black-on-white. The very earliest figurative designs—the famous motifs of the Mimbres—began to appear just at the end of Style I and became more common, though they were still relatively rare, during Style II times (pl. 2). Also, in Style II times more open space was left in the centers of bowls than had previously been the case (pl. 3).

Overall, Style I painting is similar to and of the same quality as contemporaneous work done in other parts of the Southwest. There is little in it to predict the forthcoming florescence of Mimbres pottery painting. Style II saw a dramatic improvement in the sophistication of designs and the quality of execution. Clearly, something changed in Mimbres culture to stimulate these developments, which did not arise in the Southwest as a whole.

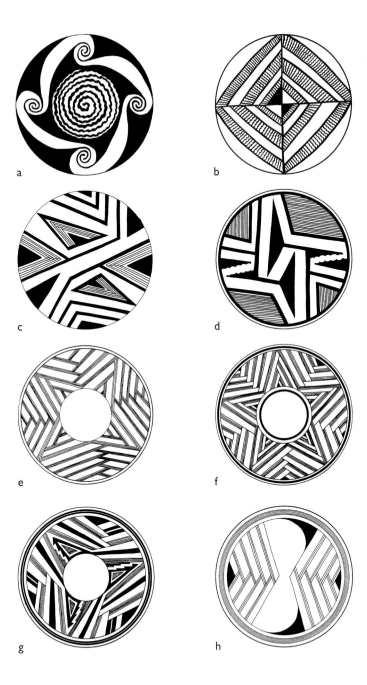

a

b

c

d

e

f

g

h

The evolution of Mimbres pottery designs from approximately A.D. 750 to 1150. Drawings by Harriet Cosgrove, reproduced from *The Swarts Ruin*. *a,* Early Mimbres Style I bowl with wavy-line design (Cosgrove and Cosgrove's pl. 109D); *b,* Mimbres Style I bowl with wavy-line hachure (pl. 108D); *c,* Mimbres Style II bowl, the design field extending to the bowl's rim (pl. 114C); *d,* Mimbres Style II bowl, the design field not extending to the bowl's rim (pl. 113D); *e,* Early Mimbres Style III bowl without a rim band (pl. 122E); *f,* Mimbres Style III bowl with a single rim band (pl. 122F); *g,* Mimbres Style III bowl with two rim bands (pl. 124F); *h,* Mimbres Style III bowl with multiple rim bands (pl. 123B).

What is called Style III begins with the lines bounding the hachure lines becoming the same width as the hachure elements, or else the hachuring becomes long parallel lines with no bounding lines at all (p. 27, *e*). The Cosgroves called this Classic Black-on-white. Within a generation, painters had added a single fat band below the rim and above the design field—a rim band (p. 27, *f*)—and the frequency of figurative elements increased dramatically. Within another generation or two, two fat rim bands were common, and shortly afterward artists began to use a profusion of bands, both fat and thin (p. 27, *g, h*). It was during the time span of this last style that Mimbres art reached its pinnacle.

At the very end of the Mimbres sequence a few bowls had no rim bands but simply a broad line pendant from the rim, along with designs well separated from it in the center of the bowl. A number of these bowls are heavily worn on the interior from use. As yet there is no consensus among scholars about which characteristics are indicative of a late Style III. Once Style III was reached, Mimbres pottery painting seems to have undergone no further improvement in quality. Early Style III bowls with no rim band or only a single band can be just as sophisticated and beautifully rendered as late Style III vessels. The extraordinary achievement of the Mimbres potters ran from the late A.D. 900s or 1000 to 1100 or 1130, a span of some five or six generations.

By the Classic or Style III period, rim bands, either thick, thin, or in multiples, appeared on almost all Mimbres bowls. Rim bands were in common use across much of the Southwest at this time, but the variety of numbers and combinations of thick and thin rim bands seen on Mimbres bowls is unique. This is but one example of the ways in which Mimbres artists took widely used design features and elaborated on them, making them far more visually interesting than their contemporaries did (pl. 20).

Intrigued by the great variety in Mimbres rim bands, scholars have attempted to understand their imagery. Were multiple rim bands a form of counting? Might they have had calendrical significance? Might different social groups such as clans have had unique combinations of wide and thin rim bands? Were the rim band patterns a form of artist's signature? Did the patterns have symbolic meaning? In spite of efforts to decipher the bands, at this point none of these possibilities is convincing. This does

not mean that we will never discover a Mimbres Rosetta stone and unlock their meaning, if any, but we have not done so to date.

Another striking aspect of Mimbres pottery is the layout or overall structure of its designs. Some bowls, both geometric and figurative, display rotational symmetry, in which elements are repeated by being copied after the bowl has been rotated. Rotational symmetry may be bifold, threefold (pl. 20), or even fourfold or more. It stands in contrast to mirror symmetry, in which an image appears as if one part is a mirror reflection of another part. Attempts to interpret these forms of repetition have yielded little of interest. All the pottery traditions of the Southwest used similar types of layouts, and they existed for hundreds of years. The Mimbres were in no way unique in their use of rotational symmetry or in their willingness to repeat elements in different ways. Any meaningful interpretation would have to apply to the Southwest in general and would tell us nothing about the Mimbres in particular. What makes Mimbres pottery so fascinating is that these artists used the same basic elements that everyone else used in the prehistoric Southwest, but came up with a more aesthetically pleasing and richer repertoire of results. It is not the similarities that command our attention but the differences between the Mimbres and the rest of the Southwest. The Mimbres people took commonly used concepts and broke away from normal usage. They took what had been mundane and made it elegant. We are still asking why.

Of course it is the figurative designs that are the most engaging and appealing. Roughly one bowl in four has figurative elements, counting only the obviously figurative designs. I suspect the actual number is higher because some abstract renderings that appear to us as geometric probably appeared to Mimbres people as figurative. Some scrolls, for example, look very much like the horns of bighorn sheep; some serrated or stepped triangles might have been bird's wings, clouds, or other figurative motifs that we cannot recognize; many dots and diamonds might be eyes (pl. 17)—and the list goes on. Moreover, many "figurative" bowls have geometric zones, and sometimes the figurative and geometric are so cleverly intertwined that one cannot separate them (pl. 19). Rarely is a figurative animal depicted without part of its body being composed of one or more geometric elements (pls. 6, 16). The distinction between geometric and figurative elements seems not to have been germane to the Mimbres people.

Researchers have looked at Mimbres pottery to see whether figurative designs might have been associated with particular age groups, sexes, or even villages. Any patterns, if they exist, are slight, and conclusions remain tentative. Children were buried with bowls bearing figurative designs slightly more often than were adults. On average, however, children were buried with smaller bowls than those of adults, and it turns out that smaller bowls tend to have figurative elements more often, so the correlation is probably false. There is a slight tendency for bowls from villages at lower elevations to depict animals such as pronghorns, which live in that habitat, more commonly than do bowls from higher-elevation sites, where, for example, deer would have been more numerous. But the association is weak, and the considerable trade in ceramics might have obscured any patterns in the correlation of designs with particular villages. At this point, such approaches have not gotten us far, and they assume a certain simplistic quality in design construction. It is more likely that these sophisticated artists were not so constrained as to paint a deer only because that was what lived nearby, or always to paint the same set of rim bands. Mimbres potters were simply too inventive to have behaved that way. It is more fruitful to look elsewhere for insights.

What Is Being Depicted?

It is the figurative imagery of Mimbres bowls that fascinates so many people today. Yet those who would interpret the images must beware: Fake Mimbres bowls abound, and one can be sure the depictions are truly ancient only when the bowls have been collected by archaeologists and reside properly in museums, like the collection from Swarts Ruin.

Some of the bowl imagery is fairly easy to decipher, because it draws directly on objects that archaeologists have found and whose uses they understand. Shell bracelets, for instance, are depicted on pottery bowls, sometimes by themselves (see p. 18) and sometimes being worn by people. The bracelets, made from shells of the *Glycymeris* clam, which lives in the waters of the Gulf of California, were traded to the Mimbres, and a number were found at Swarts Ruin (see p. 18). Items of jewelry, bows and arrows, and sticks for hunting rabbits are depicted so accurately in Mimbres painting that they are easy to link to their real-life counterparts.

Some of the animals drawn on the bowls are also clearly identifiable. Deer and pronghorns, which made up the bulk of the meat from large mammals consumed by Mimbres people (something we know from studies of the animal bones from various sites) are distinctly depicted (pls. 5, 6). Rabbits are, too (pl. 13). Judging from the relative sizes of the ears and the linearity of the bodies, it appears that jackrabbits were more commonly shown than cottontails, although both were present in the valley. Parrots, turkeys, quail, and some other birds are clearly rendered, and turtles, horned toads, skunks, bears, and raccoons are fairly obvious (pls. 21–23).

Other identifications are a bit trickier. Some animals shown on Mimbres bowls appear to be carnivores, but it is not at all obvious which species they are. Felines that might be either mountain lions or bobcats are drawn not much differently from canines that might be either coyotes or dogs (pl. 23). Birds with pointed wings that might be swallows or swifts could also be eagles or hawks in flight or even the mythical "knife-wing" bird of the modern Pueblos.[17] Similarly, some insects appear fairly clearly to be spiders, millipedes, and grasshoppers, whereas others are harder to classify (pls. 10, 19). Snakes are often depicted as well. Some of them clearly are rattlesnakes, but at least some others appear to be the Southwestern equivalent of the Mesoamerican Quetzalcóatl—the feathered serpent god, known among the Tewa Pueblos today as Avanyu. In other words, some animals seem fairly obviously to represent particular species, whereas others are fanciful or mythological beasts.

The harder part of identifying what is being depicted on Mimbres bowls arises when images appear to the modern eye to be somehow "wrong" or depicted inaccurately. Some of this apparent inaccuracy is a result of the artists' having followed cultural canons—agreed-upon methods of rendering things—that we do not share. Some of the canons of Mimbres art are reasonably clear. There were conventions both practical, which made it easier for viewers to "read" the image, and aesthetic. Among the practical conventions, for example, arrows were shown with their stone tips sticking out of quivers, when in reality they would have been placed in quivers with the feathered ends protruding (pl. 9). A woman is shown giving birth with a baby's head and one arm appearing (see p. 17). The head in fact should face backward, and babies do not come out with their arms over their heads. But had the scene been drawn with

anatomical correctness, it would have been essentially unread-
able, because the baby would have been represented only by
a round black "head" that would have appeared as a ball.
Mimbres artists deliberately drew some things "wrong"
so that viewers could understand the drawing.

The accuracy of scale varies in Mimbres paintings.
On the bowl at right, for example, a rabbit is shown
together with a distinctive carved stick that looks
superficially like a sword but was probably used by
Mimbres men ceremonially or as a badge of office.
Judging from archaeological finds of such swordlike
carved sticks, the rabbit and stick are correctly propor-
tioned relative to each other. On another bowl, however,
what are obviously the same kinds of swordlike sticks are
drawn the same size as a pair of insects (PM 24–15–10/96026).
Similarly, a distinctive basket with parallel sides on its lower half and a
flared upper half is shown on at least a half dozen bowls (pl. 12). These baskets appear
to have been about three feet high in real life, judging from their depictions on most
bowls, yet one basket has an inchworm on top that is bigger than the basket.

Another set of conventions involved the use of perspective. Many years ago, Lois
Weslowski, then a graduate student at the University of New Mexico, took a large
number of photographs of Mimbres bowls and sat down with several Hopi men to
obtain their opinions about the imagery on them. Barbara Holmes undertook a similar
effort with men and women from Zuni, and later Zena Pearlstone worked with other
Hopis, both men and women. Of all these Pueblo people, the Hopi artist Fred Kabotie
was the most insightful interpreter. Kabotie is famous for his own paintings and
murals, especially those painted in the 1930s at Far View Tower at the Grand Canyon,
where he incorporated Mimbres designs into his imagery.

Although much of the discussion with Kabotie and others was about what the
images meant, Kabotie was also interested in figuring out what the artists were
doing technically. He was the first to point out that the Mimbreños had at least

This carved wooden stick (PM 29-
20-10/97364) from a cave in the
mountains above the Mimbres
Valley is similar to the swordlike
object portrayed on the Style III
Mimbres Black-on-white bowl
above, found at the Swarts Ruin
(PM 24-15-10/94700, 21 x 10.5 cm).
Top, T763; bottom, T4245.1.
Hillel S. Burger, photographer.

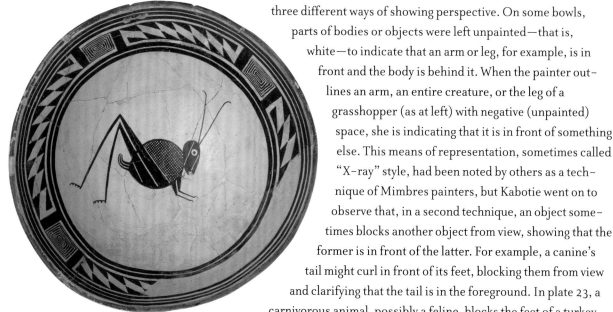

three different ways of showing perspective. On some bowls, parts of bodies or objects were left unpainted—that is, white—to indicate that an arm or leg, for example, is in front and the body is behind it. When the painter outlines an arm, an entire creature, or the leg of a grasshopper (as at left) with negative (unpainted) space, she is indicating that it is in front of something else. This means of representation, sometimes called "X-ray" style, had been noted by others as a technique of Mimbres painters, but Kabotie went on to observe that, in a second technique, an object sometimes blocks another object from view, showing that the former is in front of the latter. For example, a canine's tail might curl in front of its feet, blocking them from view and clarifying that the tail is in the foreground. In plate 23, a carnivorous animal, possibly a feline, blocks the feet of a turkey, showing that the carnivore is in front of the bird.

Mimbres Black-on-white bowl, Style III, with grasshopper design. This painting uses the "X-ray" style of representation: Both hind legs, outlined in unpainted white, show through the body even though the figure is seen in profile. Swarts Ruin, PM 25-11-10/94817, 24 × 10.5 cm. T4838.1. Hillel S. Burger, photographer.

The final form of perspective is similar to the Western convention in which relative size is used to show what is near and what is far away. Two men engaged in the same activity may be different sizes, for example, telling us which is the nearer. On one vessel from another site, a person is shown twirling a feather-covered object that is drawn very large, so that we know it is being twirled in the viewer's direction.

Considerable discussion has been devoted to the species of fish represented in Mimbres drawings. It appears that certain artistic conventions were used to make a fish a fish, resulting, for example, in fins that are in the wrong place. One bowl (opposite) has fish with featherlike appendages on their heads. Some of these fish are clearly composite animals (displaying characteristics of several different species), and others are transformational ones (undergoing transformation from one species to another). The depictions seem to represent local fish drawn with nonfish attributes in order to show that they are not merely fish but complex, iconographically laden images. In order to have seen exotic fish with similar attributes—if they existed at

all—Mimbres artists would have had to travel hundreds of miles to the ocean and gone far out to sea, which seems unlikely.[18]

The hardest part of understanding what is being depicted on Mimbres bowls lies in interpreting the meanings of the images (pls. 7, 11). Many people have tried to do so, but they stand on shaky ground. It does seem clear, however, that some images derive from the religious pantheon shared by certain peoples of Mesoamerica and of the Southwest. The feathered serpent, Quetzalcóatl, and the Hero Twins are the most obvious such components. Others probably relate to widely held Native American beliefs. For example, most Native Americans see a rabbit in the moon, rather than a man. It was likely this idea that resulted in rabbits' being depicted with crescent backs, like the one on page 33, and juxtaposed with crescent moons on Mimbres bowls. Water-related animals—dragonflies, fish, turtles, and the like—were portrayed far more commonly than one would predict from the fauna that was being eaten and used. Perhaps this reflects the importance of symbolizing water in a semiarid land. Clearly, ceremonial acts are shown on some bowls (pl. 14), and the suggestion that painters were depicting the twin war gods and other supernaturals, some of them much like Mesoamerican gods, is persuasive.

Fred Kabotie tied many of the images to meanings and attitudes of the present-day Hopis. Although the Mimbres were not Hopi, the two groups clearly shared much of the pan-Southwestern tradition. Kabotie also pointed out that figural transformations were repeatedly depicted. He convincingly showed that several bowl paintings whose images had previously been interpreted as fish eating humans instead depicted transformations of fish into humans beings. Other so-called composite figures might similarly be transformational rather than representing mythical animals with attributes of different species. Kabotie knew that some men depicted on Mimbres vessels—like contemporary Hopis during ceremonies—wear distinctive face painting, and he

Mimbres Black-on-white bowl, Style III, depicting two fish with what appear to be feathers on their heads. Swarts Ruin, PM 26-7-10/96020, 16 x 6.5 cm. T 4247.1. Hillel S. Burger, photographer.

believed he could identify the twin war gods by their face markings. Many of his ideas, though by no means all, are presented in his 1949 book *Designs from the Ancient Mimbreños with a Hopi Interpretation.*

Finally, some of the images on Mimbres bowls might reflect the artists' having manipulated meanings or made statements about relationships in their lives. Some such manipulations, done by juxtaposing ambiguous elements (pls. 10, 23) or by reversing or replacing elements—such as a fishtail being replaced by a bird's tail— may have been humorous, and others serious. The Pueblo clowns who perform at public ceremonies nowadays provide both entertainment and social commentary. Pueblo Indians certainly pun, and sometimes their puns are visual. For example, in the 1890s some Hopis kept a stuffed mud hen as a standard atop a kiva where clowns prepared for performances. In Hopi the words for mud hen and clown are approximately the same, *tsuku.*[19] Alternatively, the Mimbres might not have been punning with some of their juxtapositions of elements but making social commentaries or other reflections on their lives.

But all these observations about what is being depicted raise more questions than they answer. Did horned serpents represent the same deity in Mimbres culture as in Mesoamerica? Did flowers simply represent flowers or did they symbolize the flowery world, a conceived afterlife shared by some Mesoamerican and Southwestern peoples? Had there been direct and recent connections between Mesoamerican and Mimbres people that could account for such shared beliefs, or was this instead a case of an ancient shared pantheon and associated ideas? Were ceremonies and supernaturals painted because the bowls were used in rituals or because these things were the focus of Mimbres oral history and therefore obvious topics to depict? Could humor and rich symbolic meaning have gone hand-in-hand? It is easy to make such suggestions, but so far analyses have not been deep enough to put them into a meaningful social context. In many ways the study of Mimbres imagery is still in its infancy.

Who Painted the Bowls?

Did women or men paint the Mimbres bowls? Although this question is of interest, a far more fascinating problem is that of the social role of the painters in Mimbres society. But the one question leads into the other. Most traditional societies organized as "tribes," as the Mimbres must have been, have a fairly strong sexual division of labor. Among the historic Pueblo people, men did the weaving, women made the baskets, men farmed, women ground the corn, and so on. And women made the pottery. Although it is dangerous simply to draw analogies from the present to the past, it is likely that one sex alone was responsible for making pottery in Mimbres society. This does not mean that there were no special circumstances under which the other sex might have painted bowls (pl. 5), nor does it preclude unique individuals' having performed tasks usually done by the opposite sex. For example, Navajo women weave rugs, but one of the great Navajo weavers was Hosteen Klah, a medicine man who wove a set of rugs with designs in the style of dry paintings (sand paintings), which were traditionally made by male ceremonial practitioners.

We can be reasonably sure, however, that Mimbres bowls were made predominantly by one sex. We know that women made the pottery historically in the Southwest, and at least one burial of a Mimbres woman was accompanied by a pottery-making tool kit. One Mimbres bowl shows a woman making a large jar.[20] The evidence, to be sure, is not overwhelming, but it is enough to suggest that women were the potters in Mimbres society, and I make that assumption in this discussion. (There is also a possibility that women made the bowls and men painted them, but we lack the evidence to present this as a likelihood.)

Did every woman make and paint bowls? Or was this the work of a few specialists in each village? Perhaps some villages had no bowl makers at all. I believe there is considerable evidence that only a few women made most of the bowls, and it was perhaps this specialization that led to the unique qualities of Mimbres ceramic art. Among several lines of evidence that point to specialist potters, one is our ability to recognize the work of individual artists.

Most prehistoric art is anonymous the world over. Not only do we not know the names of the artists, but we rarely even attribute particular works to particular, unnamed individuals. In the Aegean world it has been possible to recognize individual hands for Classic Greek vases and for earlier Mycenaean jars. Christopher Donnan has been able to make similar attributions for Moche fineline vessels (made circa A.D. 100–600) from the north coast of Peru.[21] But for the dozens if not hundreds of pottery traditions around the world, these are very few examples of researchers' having been able to link artists to particular vessels. Moreover, recognition of individual artists seems to be the end of the story in these studies. Little thought has been given to what we might learn from such observations. I believe we can learn a lot, but first I consider how we recognize the artists themselves.

Before starting, we need to consider what we mean by "an artist." Artists do not always work alone, creating a piece from start to finish without the help or influence of anyone else. For example, the Tewa artists María and Julián Martínez began working as a team in the first decade of the 1900s at San Ildefonso Pueblo in northern New Mexico. María fashioned the pots, and Julián painted them. The famous potter Nampeyo at Hopi taught her daughters Annie and Fannie to paint, and in her later

years, as her eyesight failed, she made the vessels and one of the daughters, usually Annie, did the painting. Even experts have a difficult time differentiating the work of Nampeyo and Annie. This situation is no different from that of the old masters of Europe, who had assistants and apprentices. Great scholarly debate is expended over whether a work is by the master or an assistant, and at least some of the time the answer must be both.

For prehistoric pottery, such nuances are essentially beyond our ability to resolve. Mother–daughter or perhaps aunt–niece or other such dyads who worked together must have been common. Probably several members of the next generation would work with a master potter. Those with real aptitude might have continued in that role while the others moved on to other tasks. When I use the term *artist,* then, I am referring to either an individual or a two–person team working closely together. I do not think there were large groups including a master, apprentices, and assistants among Mimbres potters, as was the case for European painters and Chinese bronze casters. I do think related pairs of women probably did very similar work or even worked on the same vessels to such a degree that we cannot separate their individual contributions. Fortunately, whether we are dealing with individuals or related pairs of potters does not really matter much.

Early on, Hattie and Burt Cosgrove noted that several bowls from Swarts Ruin were extremely similar to one another, but they drew no conclusions about individual makers. No one pursued the idea that individual painters might be recognized in Mimbres pottery until artist Tony Berlant suggested in the mid–1980s that one set of bowls depicting rabbits and another set depicting front–facing men had been painted by the same person.[22] There matters lay for another decade, until, spurred in large part by Donnan's work on Moche pottery, I decided to tackle the issue again.

I approached the problem of identifying Mimbres artists in two ways. First, I selected a small number of motifs and gathered photographs of every known example of them on Mimbres pots. Most of the photos came from the Mimbres Archive, a collection first assembled in the 1970s and currently housed at the Maxwell Museum of Anthropology at the University of New Mexico in Albuquerque. This archive contains images of more than six thousand bowls. Because it was impossible to deal with so

many, I initially chose bowls that depicted humans, turtles, rabbits, and scrolls (pl. 15). It had been bowls depicting these motifs that the Cosgroves and Berlant had earlier thought might have been made by the same person. With the assistance of Margo McC. Ellis, I pinned the pot images to a large bulletin board, and Ellis and I then invited five scholars and two Hopi artists, Mike Kabotie (son of Fred Kabotie) and Delbridge Honanie, each to arrange the images into groups they thought might have been the work of the same person.[23]

A number of sets of bowls emerged, but several problems arose, too. Some people were what I call "lumpers" and others "splitters," so the same bowls were arranged in various ways. Most people saw connections among bowls, but they had difficulty defining where the work of one artist ended. Some saw certain bowls as having been made by a single artist, whereas others saw the same bowls as the work of two artists who might have been related. On the other hand, the more familiar viewers were with Mimbres painting, the more likely they were to arrange the bowls in similar groups. In the end, I arranged the artists' sets according to what I felt was a loose consensus of opinion. In all, each of some thirty groups of bowls depicting one or more of the selected motifs seemed to have been painted by the same artist. Not a bad beginning. But with far from complete agreement among the people who had sorted the bowl photographs, how much confidence could one place in these results?

This is where my approach differs from those of other researchers. My goal is not attribution per se. I am not trying to determine whether a particular painting is by Rembrandt or a particular Greek vase is by the so-called Berlin Painter. Such attribution might greatly enhance the commercial value of a work, but alone it tells us little about past cultural behavior, which is our goal. My approach is to try to be correct most of the time, without having to be correct in each and every case. If we are interested in how many painters there were, how specialized they were, how far their pottery was exchanged, or even how varied an individual's motifs were, then each proposed attribution does not need to be valid in order for the general pattern to be correct. A few missed attributions, a few bowls mistakenly added to the work of an artist when they were in fact not painted by her, matter little when we are looking at the big picture. We are searching for patterns of behavior, not trying to prove

that a particular bowl was made by a particular painter. This makes our lives much easier.

As the second part of the project, we devised several tests to see whether our attributions were likely to be valid. We used aspects of the designs and information about where the bowls had been found that were not used in making the attributions initially. We reasoned that if the attributions were generally correct, then we could expect three things. First, the bowls in a set should have been made at roughly the same time. No painter worked for more than about twenty-five to thirty years. (In the absence of eyeglasses, old age would have reduced close-up vision and it would have been impossible to paint the fine lines.) And indeed, bowls considered to have been painted by the same person did turn out to be roughly contemporaneous. The bowls could be placed in the temporal styles discussed earlier, each of which lasted a generation or two. We found no late Style II and middle Style III bowls, for example, in the same sets. Virtually all bowls in each set presumed to have been painted by the same hand had been made close enough in time to have been the work of the same person.

Second, bowls by the same artist should have been found in greater numbers at some sites than at others. We know that Mimbres pottery was traded among villages, but we expected that a good bit of the work of the artist herself would have remained in the village where she lived. Therefore, of any six or eight bowls thought to have been painted by the same artist, several of them should have come from the same site. Unfortunately, roughly half the bowls represented in the Mimbres Archive had been dug up and sold by looters, so we had no idea which village they came from. But the archive also includes images of bowls from Swarts Ruin and other Mimbres sites that were properly excavated and recorded. Although the lack of provenance for many bowls made our task more difficult, we were able to see that bowls attributed to a single painter did come from the same site far more often than chance alone would have predicted.

The final test is that bowls from the same hand should have been made from the same clay, regardless of where they were found. This test requires doing chemical analyses of complete bowls, a research direction that is just beginning. Once the analyses are completed, this should be the most informative of all the three means of verifying the general validity of the artist sets.

The effort to identify Mimbres vessels made by individual artists got a boost in 2003 when the Peabody Museum began to develop an exhibit on the Mimbres using bowls excavated from Swarts Ruin. As curator of the exhibit, I sent photographs of 175 bowls from Swarts Ruin to Tony Berlant, asking his opinion about which ones to display. Berlant had taken part in the previous exercise in spotting Mimbres artists, and together we had had more recent success in doing the same thing with prehistoric Hopi pottery.[24]

As Berlant sorted through the photographs, he began to see, even in this small sample, bowls he thought had been painted by the same person—such as those shown in the frontispiece and in plate 25. It made sense. These 175 bowls had been selected because they seemed to be the most artistically accomplished bowls from the site. If my colleagues and I had already selected work by the best artists, then much of the work of any particularly good artist should have been in the set, especially if most of her bowls had been used and deposited at Swarts Ruin. We likely were looking at the best work by the best artists at Swarts, and it was reasonable to be able to recognize the work of some of them.

Most of the time, Berlant identified only two or three bowls by the same hand, as one might expect from such a small sample, so the results were not overwhelmingly convincing. Nevertheless, a number of the paintings were strikingly similar (pl. 24). This different way of approaching the problem of identifying artists greatly increased the likelihood that, overall, we were recognizing the work of actual artists and not making things up. Importantly, it was not just a few of these 175 bowls that appeared to have been made by the same artist but numerous groups of bowls by a significant number of artists.

Looking back in time and seeing the work of a single artist makes the creators of these bowls much more real than they were before. But there is more. Recognizing individual artists helps us estimate how many artists lived in Mimbres society at any one time. The more traditional model of prehistoric pottery making in the Southwest has a member of every family making its own pottery, so that in a village like Swarts, with perhaps 150 people in some thirty families, we would expect about thirty bowl makers and painters in each generation. Over five or six generations, the Swarts vil-

lage might have been home to 150 or more different artists. Some of their bowls were presumably traded out of the village, and bowls from other villages were imported. With so many artists, so many vessels, and yet a limited number of bowls by each individual represented at the site, the likelihood of recognizing bowls made by a single person should be small.[25]

If we accept, however, that specialists made the pottery, then the traditional model is turned on its head. If only a few artists were working at any one time, then many more of the bowls from a given site must have been made by the same artist, and it should be easier to spot the work of a single person. In other words, the fewer the artists at work at one time, the easier it should be to recognize the work of individuals. That we can in fact recognize the work of so many artists implies that indeed few of them were working at any one time. (Of course the ones we recognize did not all work at the same time but spanned five or six generations.) Taking the most reasonable estimates of how many artists might have worked at one time (30–50) and knowing the number of villages that were occupied contemporaneously (20–25 major villages) allows us to deduce that only a few pottery painters were alive and working in any one village at any given time—on this reasoning, most likely only two or three.[26]

The implications of this deduction make sense, because they help explain why Mimbres art became so good, why artists' conventions were so widely adhered to, and why the design styles evolved so regularly. All these questions are easily resolved when one concludes that there were few artists interacting with each other at any one time.

Although speculative at this point, a scenario can be described for the development of the Mimbres painting tradition. Suppose that, by luck or because of some special social situation, the work of a few artists stood out, and their pottery became sought after. They began to make pots more frequently because their work was in demand, and artists with lesser skills stopped making painted bowls because theirs was not. As the number of artists declined, each would have been better able to recognize the work of every other, and it would have been easy to conform to the same canons and general styles. Once some threshold was crossed, the process could have fed upon itself. It would have become ever more important to the general population to obtain a bowl by one of the recognized artists, restricting the number of pottery producers still

further. These artists might have engaged in friendly competition, but they probably avoided copying. At any given time, one artist might have been recognized as the "great one" and might have set the direction for style evolution, but the process could also have occurred without such inspirational leaders.

This scenario would account for the smooth and orderly evolution of the rim band and hachure treatment on Mimbres bowls. If hundreds of contemporaneous artists had been involved, one would expect a plethora of different treatments and a lack of co-occurrence of multiple elements. But this did not happen. Interaction among only a handful of artists would also explain the broad use of certain artistic conventions. It might even explain the wonderful ingenuity we see in Mimbres painting. For example, when one artist came up with negative painting—a technique in which, although the design is in black paint on a white background, the image appears as if it were in white paint on a black background (pl. 18)—another might have responded by merging figures into geometric designs, while someone else developed the narrative scene or visual puns—each trying to outdo the other, not by copying but by trying to produce a distinctive, signature style. Finally, if a relatively small number of painters were working when the Mimbres social system began to unravel, it would have taken the loss of only a few of them to bring the tradition to an end.

WHAT HAPPENED TO THE
MIMBRES PEOPLE?

We cannot fully understand Mimbres culture, and especially what eventually happened to it, without considering how the people lived and what effects they had on their environment. From excavations begun in the 1970s, researchers have been able to add new dimensions to the work of Hattie and Burt Cosgrove. The survey work described earlier tells us that the Mimbres population grew five- to tenfold between A.D. 200 and 1100. This growth was enabled by particularly good—that is, wet—weather from 900 to 1100. By about 1100, however, the population was exceeding the land's ability to support it. Most of the trees in the bottom of the Mimbres Valley had been chopped down, and sycamore trees and muskrats had become locally extinct because of habitat disturbance. These changes have been observed in the pollen collected from excavated rooms and from grinding tools and in charcoal and seeds from burnt roofs and hearths. Analyses of animal bones from trash deposits show that deer and pronghorns grew ever scarcer, and ultimately rabbits became the main source of meat. The locations of sites also show that the Mimbres people were forced to farm increasingly marginal land.

As the weather deteriorated in the 1100s, becoming cooler and dryer, the Mimbreños, like most of their contemporaries in the Southwest, faced a resource crisis. There were too many people for the now less productive land to support. The regional population plummeted, and the social system underwent a major transformation—what some call a collapse. It is unclear whether the decline was a result of the population's inability to reproduce itself adequately, of out-migration, or, perhaps most likely, of both. In any case, the same thing was happening all over the Southwest. The great towns of Chaco Canyon and its environs were abandoned, and the Hohokam of the low desert, too, underwent a cultural crisis at this time.

By around 1130, all the Mimbres villages, including Swarts Ruin, were completely or partially abandoned. Painted pottery had ceased to be produced, and Mimbres culture as we think of it had disappeared.[27] Just what happened to the survivors of these villages remains a mystery. Soon after the Mimbres collapse, the site of Paquimé (Casas Grandes) in northern Chihuahua—the largest town ever built in the greater Southwest—began to flourish. Sites bearing architectural and ceramic similarities to Paquimé were soon being built in the Mimbres Valley, probably within fifty years but certainly within one hundred. Opinions differ about the role Paquimé played in the Mimbres collapse and the subsequent history of the Mimbres people, but it is difficult to imagine that the effect was not significant.

Archaeologists assume that some of the descendants of the Mimbres ultimately became parts of the Pueblo peoples, such as the Zunis and Acomas, in present-day New Mexico and Arizona, but no specific links have been established. Some of the Mimbres likely became linked to the Casas Grandes people to the south, and in turn these people may have been ancestral, in part, to the Tarahumaras who live in the nearby mountains today. Although these possible links to the present are tantalizing, the disappearance of the Mimbres culture remains one of the great unsolved mysteries of Southwestern archaeology.

MIMBRES DESIGNS AS INSPIRATION

Hattie and Burt Cosgrove's *The Swarts Ruin* was the first book on Mimbres culture and pottery that was readily available to Pueblo people in New Mexico and Arizona. Around the time of its publication, several potters in New Mexico had already begun to take earlier pottery color schemes and designs in new directions. María Martínez and her husband, Julián, at San Ildefonso Pueblo, had taken an earlier Rio Grande tradition of burnished black pottery and begun to produce their famous black-on-black ware. Soon many of their designs, drawing from Hattie Cosgrove's illustrations, were inspired by bowls from Swarts Ruin, especially those with the feather motif. Thus they merged several ancient traditions in a unique way.

At Acoma Pueblo, Lucy Lewis began to use prehistoric geometric designs on her pottery in the 1920s, but it was not until she was given a copy of *The Swarts Ruin* by Harry P. Mera, an archaeologist at the Museum of New Mexico, after the Second World War, that she began to incorporate animal figures in the Mimbres style into her

The feather motif on this Style III Mimbres Black-on-white bowl from the Swarts Ruin (PM 25-11-10/ 94785, 18 x 7 cm) was an inspiration for San Ildefonso potter María Martínez's black-on-black adaptation of the design. Private collection. Top, T4300.1; bottom, T2127. Hillel S. Burger, photographer.

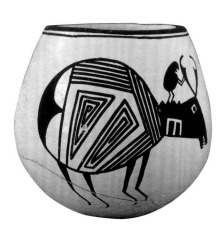

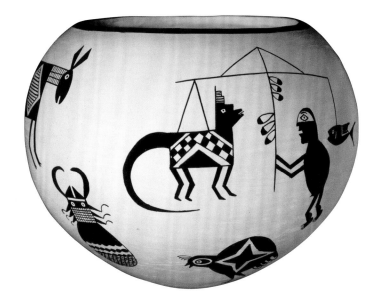

Many of Acoma potter Lucy Lewis's designs, like the pronghorn and man on this miniature jar (above left, PM 995-29-10/73753, 7.3 x 7.7 cm), were inspired by Mimbres motifs. This image borrows from the design on the bowl in plate 6. Lucy Lewis's daughter Emma Lewis was commissioned by the Peabody Museum to create the pot at right (PM 2003.6.1, 16.5 x 13.1 cm), which reproduces numerous Swarts Ruin motifs, including an image from the bowl in plate 16. Left, T2146; right, T4315.1. Hillel S. Burger, photographer.

work.[28] Never slavishly copying designs, Lewis mixed elements from different bowls into her painting. This tradition has been continued by others at Acoma, including Lucy Lewis's daughter Emma Lewis, who used the bowls from Swarts Ruin as inspiration for the jar shown at right above.

More recently, Pueblo artists such as Tony Da, grandson of María Martínez, have taken images from vessels found at Swarts Ruin (pl. 21) and other Mimbres sites and used them in media other than pottery. Da's painting of a Mimbres-inspired turtle and fish appears on the facing page. Today, almost a thousand years after the bowls were first made, Mimbres images are used in jewelry, paintings, dance rattles, and almost all the media that Pueblo artists employ.

Not only Native Americans have incorporated Mimbres designs into their work; the designs have also become a leitmotif for the romanticized Southwest. In the 1930s, the Santa Fe Railroad commissioned a complete dinner service designed by Mary Colder using Mimbres imagery. Today, everything from large metal sculptures and copper-embossed postcards to real-estate agency signs use Mimbres designs.

This untitled painting by Tony Da of San Ildefonso Pueblo uses images from two Mimbres bowls from Swarts Ruin: the fish bowl on page 35 and the turtle bowl in plate 21. Private collection. T4312.1. Hillel S. Burger, photographer.

Harriet and Burton Cosgrove gave the world a collection of bowls whose imagery enchants every subsequent generation and inspires artists of all kinds. Their report on Swarts Ruin laid out new information and raised new questions that are still being explored. Research done in the Mimbres Valley since the Cosgrove's pioneering work has helped us understand when the Mimbres lived and how they interacted with their environment. Most importantly, perhaps, we can now begin to recognize the hands of individual artists in Mimbres pottery and get an inkling of how their art might have functioned in Mimbres society. Many facets of Mimbres culture lie undiscovered still, but there is no question that this uniquely engaging and expressive art will continue to fascinate us no matter how much we learn about the pottery and the people who made it.

Color Plates

PLATE 1
Mimbres Black-on-white bowl,
Style I, geometric
26-7-10/95905
Swarts Ruin, Mimbres Valley
A.D. 750–900
Rock-tempered ceramic with
mineral paint
Diameter 15 cm, height 9 cm

THE MIMBRES BLACK-ON-WHITE pottery style, with the black occasionally turning a dark brown or even a brick color, began around A.D. 750, just about the time the Swarts village was founded. The bowls produced at that time usually had wavy lines, and the designs usually filled the entire interior surface of the bowl. Spirals, scrolls, and other curvilinear elements predominated. By around A.D. 800, greater use of straight lines was in evidence, and the wavy lines evolved into filler elements used for hachuring between wide straight lines that made up large design elements, as seen in bowl 94768 (below right). Such wavy-line hachuring was common over much of the Southwest at this time and is seen on both Hohokam and Anasazi pottery, but Mimbres painters used the design concept in distinctive ways. (Opposite: T4301.1; below left: T4223.1; below right: T4232.1. Hillel S. Burger, photographer.)

Mimbres Black-on-white bowl,
Style I, geometric
26-7-10/95894
Swarts Ruin, Mimbres Valley
A.D. 750–900
Rock-tempered ceramic with
mineral paint
Diameter 15 cm, height 8 cm

Mimbres Black-on-white bowl,
Style I, geometric
25-11-10/94768
Swarts Ruin, Mimbres Valley
A.D. 750–900
Rock-tempered ceramic with
mineral paint
Diameter 15.5 cm, height 6.5 cm

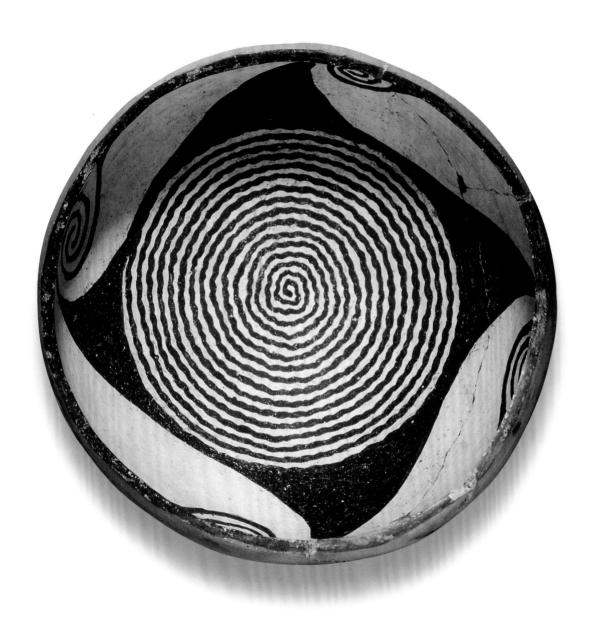

THIS BOWL IS ONE of relatively few figurative bowls made before A.D. 1000. Between about 900 and 1000, designs termed Style II were in use. This was the period when the creativity of Mimbres artists really began to express itself. Geometric designs became much more diverse and figurative bowls much more common than they had been earlier. This man–bird is executed similarly to some other early drawings of birds, but the head and especially the eyes are distinctive. The bowl shown below seems to be a more abstract version of the same image, with the heads drawn in much the same style. These two are the earliest Mimbres bowls my colleagues and I currently propose to have been painted by the same artist. (Opposite: T4252.1; below: T4216. Hillel S. Burger, photographer.)

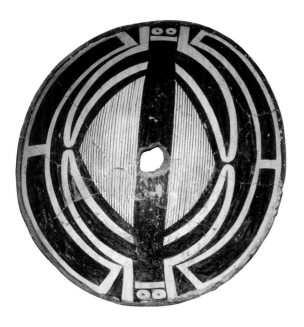

Mimbres Black-on-white bowl, Style II, abstract humans
25-11-10/94743
Swarts Ruin, Mimbres Valley
A.D. 900–1000
Rock-tempered ceramic with mineral paint
Diameter 19 cm, height 6.5 cm

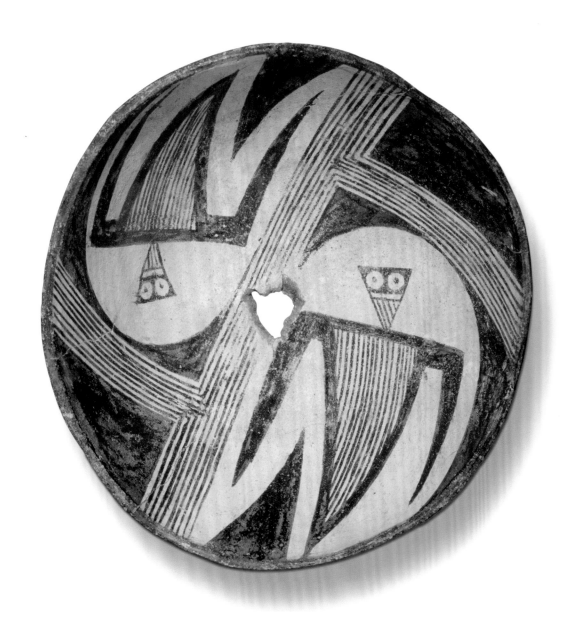

PLATE 3
Mimbres Black-on-white bowl,
Style II, geometric
24-15-10/94735
Swarts Ruin, Mimbres Valley
A.D. 900–1025
Rock-tempered ceramic with
mineral paint
Diameter 28 cm, height 11 cm

THIS VERY LATE STYLE II BOWL shows the kind of sophistication normally seen in later bowls. Notably, it displays the painter's willingness to leave more open space in the center of the bowl so that the white background and dark paint play off against each other. This trend makes it clear that the Mimbres artistic tradition had begun to diverge from the less-skilled Southwestern norm of painting by this time. It is estimated that this bowl was made between A.D. 950 and 1025, most likely just before 1000. It contrasts with the bowl below, an earlier Style II in which the center is still filled in. (Opposite: T4305.1; below: T4230.1. Hillel S. Burger, photographer.)

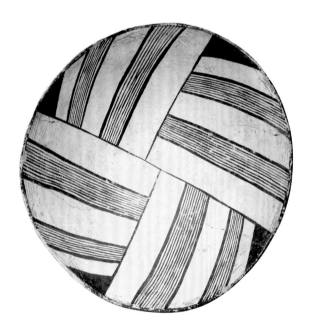

Mimbres Black-on-white bowl, Style II, geometric
26-7-10/95975
Swarts Ruin, Mimbres Valley
A.D. 900–1000
Rock-tempered ceramic with mineral paint
Diameter 24.5 cm, height 8.5 cm

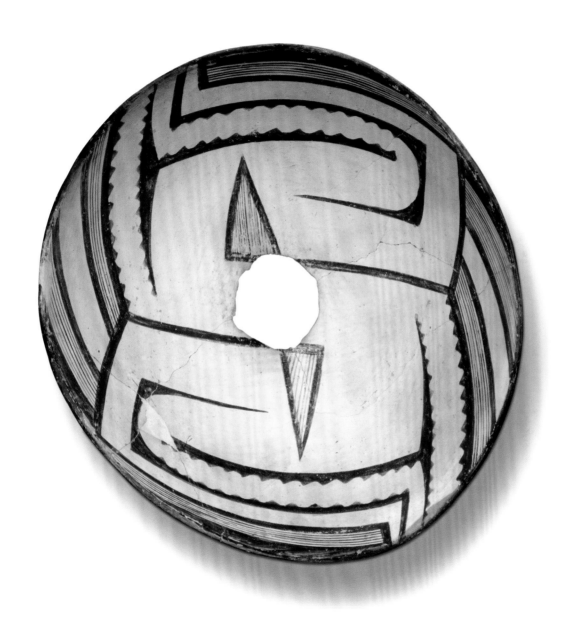

PLATE 4
Mimbres Black-on-white bowl,
Style III, bighorn sheep
24-15-10/94470
Swarts Ruin, Mimbres Valley
A.D. 1000–1150
Rock-tempered ceramic with
mineral paint
Diameter 21.5 cm, height 12 cm

ALTHOUGH IT IS POSSIBLE that the small sheep portrayed on this bowl is standing behind the large bighorn sheep, it is more likely that the artist intended to show the little sheep riding on the big one, just as a man appears to ride a cricketlike insect in plate 10. The depiction of the large ram with a turned head, both horns showing, is extremely rare for Mimbres art. Almost all animals and people are shown either in profile or, more rarely, facing front; they seldom appear with only the head turned. A bighorn sheep almost always has only one horn visible, as does a pronghorn antelope. Deer, in contrast, are always shown with both antlers, even though the head is in profile. Thus this bowl breaks several conventions of Mimbres art. (T4841.1. Hillel S. Burger, photographer.)

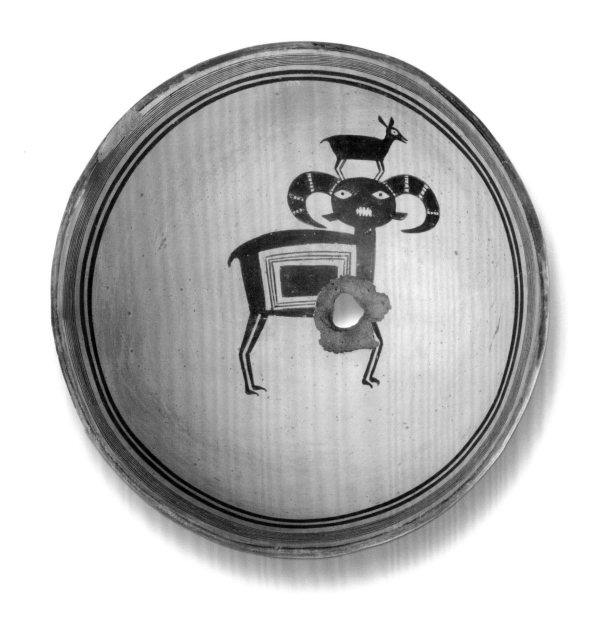

PLATE 5

Mimbres Black-on-white bowl,
Style III, humans and animals
24-15-10/94468
Swarts Ruin, Mimbres Valley
A.D. 1000–1150
Rock-tempered ceramic with
mineral paint
Diameter 19.5 cm, height 8.5 cm

THIS BOWL DEPICTING a hunter returning with his catch, a prong-horn, is quite out of the norm for Mimbres pottery. Its images appear much more like petroglyph-style depictions found in Southwestern rock art than the usual Mimbres renderings of animals or people.

Although some petroglyphs in the Mimbres region do resemble the images on bowls, in general petroglyphs are solid and less elaborate than bowl drawings, as one would expect from the requirements of pecking images on rock faces. Evidence points to women as bowl painters among the Mimbres and suggests that much of the painting was done by specialists. Might this vessel have been painted by someone who did not normally paint bowls—perhaps a man who had made petroglyphs? (T4212. Hillel S. Burger, photographer.)

The young hunter returns with his faithful companions and assistants, the dogs. He brings in his big kill, secured by his good marksmanship with the bow and arrow. His young wife is there to receive the deer, and from her, good words of thanks are expected by the husband and the mother. Naturally, a mother has outgrown her shyness at this age and openly shows her emotion of happiness. —Fred Kabotie[29]

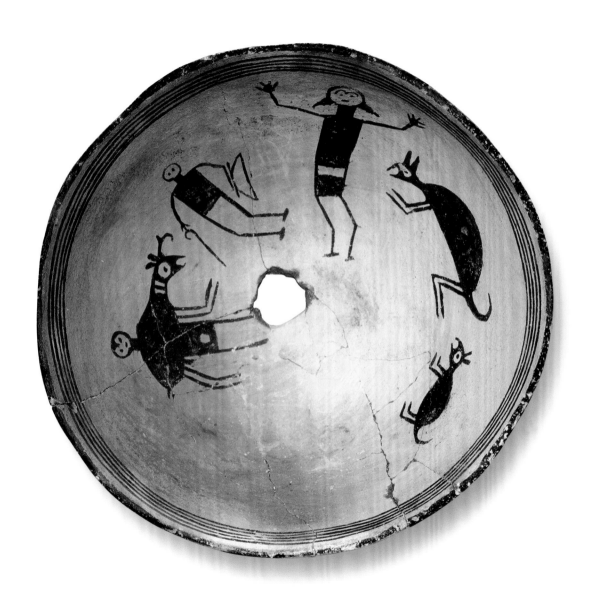

PLATE 6
Mimbres Black-on-white bowl,
Style III, man riding pronghorn
24-15-10/94490
Swarts Ruin, Mimbres Valley
A.D. 1000–1150
Rock-tempered ceramic with
mineral paint
Diameter 29.5 cm, height 13 cm

ALTHOUGH MIMBRES ARTISTS sometimes drew figures to different scales to show foreground–background perspective, in this case the man is clearly riding the pronghorn. Most likely this is an event in a Mimbres legend that is now lost to us. It is also possible that the image represents a play on words or a pun that made sense only in the language the Mimbres people spoke. The second animal on the bowl is probably a female pronghorn, since females have very small, barely visible horns. Pronghorns also have very white rumps. These look as if they are being depicted from behind instead of in profile—another example of Mimbres painters' use of artistic license to make things interpretable to the viewer. The jar made by Lucy Lewis of Acoma Pueblo illustrated on page 48 was inspired by this bowl. (T4294.1. Hillel S. Burger, photographer.)

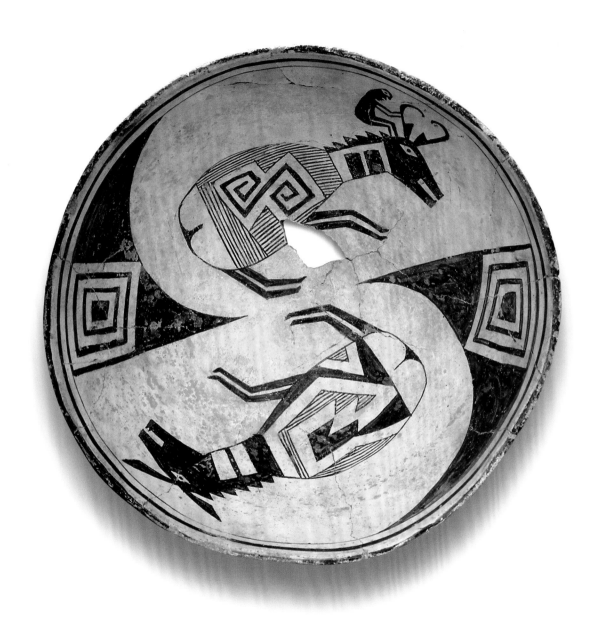

PLATE 7
Mimbres Black-on-white bowl,
Style III, two male figures
24-15-10/94502
Swarts Ruin, Mimbres Valley
A.D. 1000–1150
Rock-tempered ceramic with
mineral paint
Diameter 24 cm, height 11 cm

THIS IS AN EXAMPLE of a bowl whose meaning is particularly obscure. The posture of the two men suggests a specific activity or behavior that we cannot reasonably interpret today. Mimbres men are often shown with a band of color across their faces, much like a mask, and the way they are presented varies a good deal. No convincing suggestion has been made about what is being depicted on this bowl. The geometric elements look very much like Mimbres paintings of fishtails (and unlike the tails of birds). If these are the tails of two fish, then one is tempted to suggest that the men are swimming. With more confidence we can surmise that this painting represents the essence of a legend or an oral narrative. (T4219. Hillel S. Burger, photographer.)

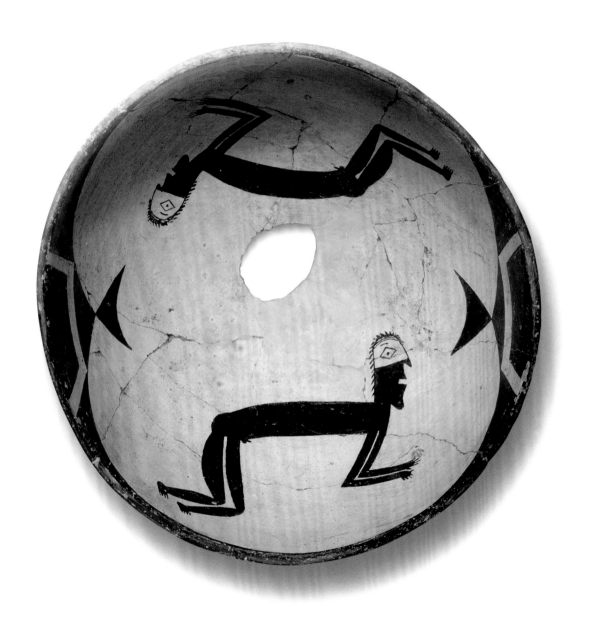

THIS GEOMETRICALLY DECORATED bowl is fired a deep red, much like the bowl shown below. The two are nearly the same size and share the use of bold designs mixed with finer elements. One is tempted to suggest not only that these vessels were painted by the same hand but that they were fired together, so that both emerged with this atypical red shade. Attributing pairs of bowls to the same artist is never as convincing as identifying a larger distinctive grouping. Future research may uncover more examples that fit with this pair and make the case more persuasive. (Opposite: T4178; below: T4208.1. Hillel S. Burger, photographer.)

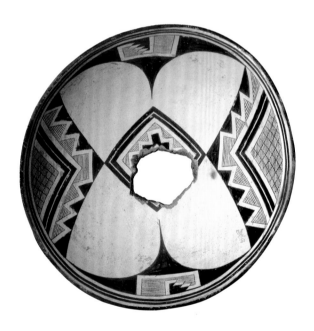

Mimbres Black-on-white bowl, Style III, geometric
26-7-10/95825
Swarts Ruin, Mimbres Valley
A.D. 1000–1150
Rock-tempered ceramic with mineral paint
Diameter 27.5 cm, height 13 cm

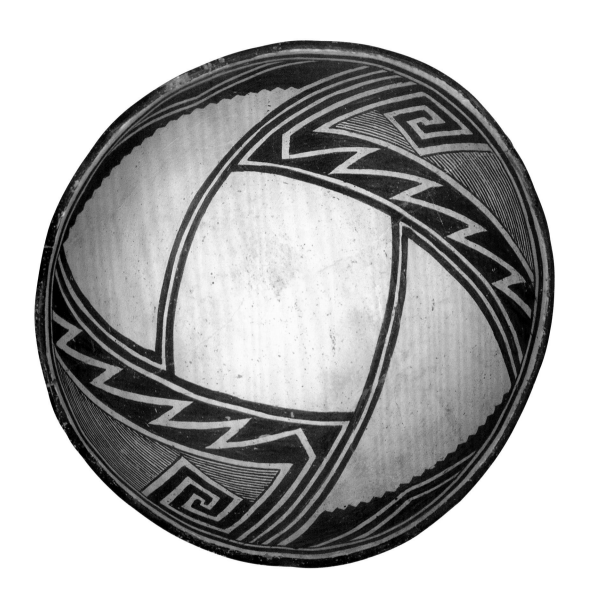

PLATE 9
Mimbres Black-on-white bowl,
Style III, man with shield and quiver
24-15-10/94584
Swarts Ruin, Mimbres Valley
A.D. 1000–1150
Rock-tempered ceramic with
mineral paint
Diameter 22.5 cm, height 9 cm

THIS MAN CARRIES a quiver and arrows in his right hand. Arrow-heads are shown sticking up out of the quiver, although arrows would have been carried with the feathered ends out in real life. This is a classic convention used by Mimbres painters to make it clear to viewers that these are arrows. The tail of a mountain lion hangs at the bottom of the quiver. Most depictions and ethnographic examples of quivers throughout the Southwest similarly show or employ the hide of a carnivore with the tail left on. In his left hand the man holds what seems to be a large shield with feathers draped along its rim. It overlaps his body, showing that it is in front, as a shield would be held. Again, other depictions of Southwestern shields have pendant feathers and are painted with bold, striking designs like this one. Why the shield is not circular, as in all other depictions, archaeological finds, and ethnographic examples, is unclear. The man may also be wearing body armor. Pueblo people are known to have used hides to make armor, and other peoples in the Americas used cotton batting and fibers. If the man were not carrying a quiver and possibly wearing armor, and if the shieldlike object were not in front of his body, one would be tempted to think it was a wing and that this was a half-man, half-bird figure. Perhaps the ambiguity was intentional. (T4214. Hillel S. Burger, photographer.)

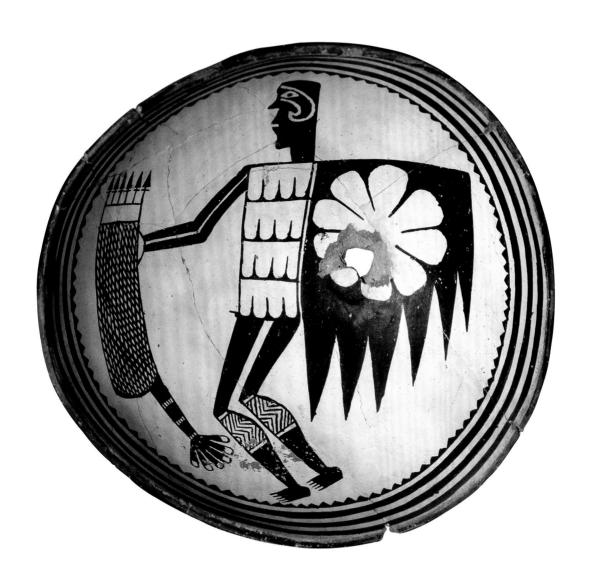

PLATE 10
Mimbres Black-on-white bowl,
Style III, man and cricketlike insect
24-15-10/94651
Swarts Ruin, Mimbres Valley
A.D. 1000–1150
Rock-tempered ceramic with
mineral paint
Diameter 20.5, height 8.5 cm

IS THIS A MAN riding on an insect? Or is the "man" also an insect? Is a man-insect copulating with another insect? Many Mimbres bowls appear to be humorous, and we know that Pueblo people today enjoy verbal puns. Hopi clowns are even known to pun between English and Hopi. As in a number of other bowls, the linkage between these two figures could be a play on words or some other form of manipulating meanings. (T4217. Hillel S. Burger, photographer.)

During the summer months, in the stillness of cool evenings, the little crickets are much alive. Their chirpings are pleasing to the ears as the Hopi farmers are on their way home from their fields. . . .

This study of a man riding on the back of a cricket looks very much like a legend. The young chief may have been deeply concerned over some serious matter and asked a cricket to deliver him to his unknown destination by jumping with its long mighty legs. —Fred Kabotie

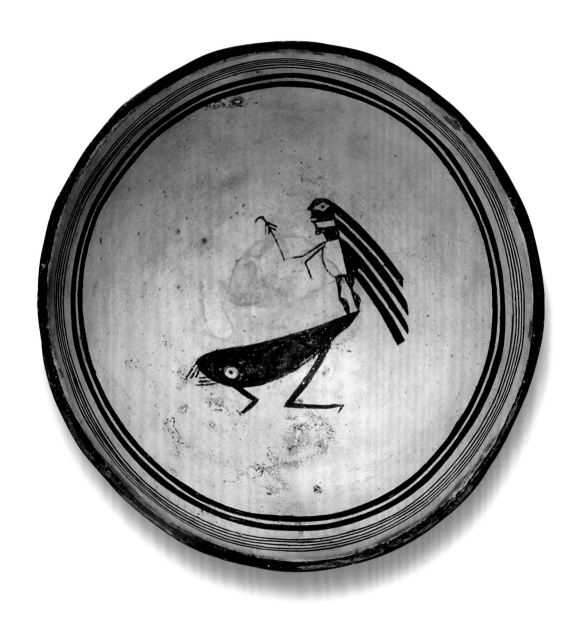

PLATE 11
Mimbres Black-on-white bowl,
Style III, figurative-geometric
24-15-10/94646
Swarts Ruin, Mimbres Valley
A.D. 1000–1150
Rock-tempered ceramic with
mineral paint
Diameter 25.5 cm, height 9.5 cm

THIS BOWL IS DIFFICULT to interpret. An incredibly complex geometric design merges into a figurative element that seems in part to be a fish. The footlike fins are a common Mimbres convention. The figure appears to be unfinished; the head is merely outlined. Yet the bowl had to have been dried for several days before firing, so its maker cannot have left it unfinished because she was in a hurry to fire it. Where it is complete, the image is very finely painted, so it does not seem to be the work of a child or novice painter. This is probably a joke, or perhaps a deliberate and very esoteric drawing, and not simply the work of a lazy painter. (T4220. Hillel S. Burger, photographer.)

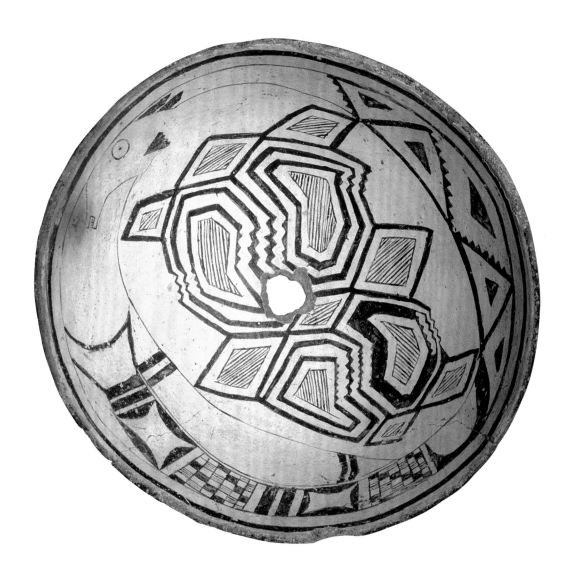

PLATE 12
Mimbres Black-on-white bowl,
Style III, men and women around
blanket
24-15-10/94717
Swarts Ruin, Mimbres Valley
A.D. 1000–1150
Rock-tempered ceramic with
mineral paint
Diameter 23 cm, height 9.5 cm

SEVERAL MIMBRES BOWLS from sites other than Swarts Ruin are known that depict four people seated around what appears to be a blanket, engaged in some activity. One of these other bowls shows what seems to be the warp and weft of the blanket, but the bottom of this bowl from Swarts is so eroded that it is unclear whether a similar rendition was painted or not. Two of the figures are women, as demonstrated by the ends of their aprons hanging behind them. The two men are more animated than is usual in Mimbres drawings. One wears a form of sash seen only on men. In the background are two baskets with conical upper portions, a typical Mimbres shape, and crooked sticks, which were probably used both for hunting and in ceremonies. (T4257. Hillel S. Burger, photographer.)

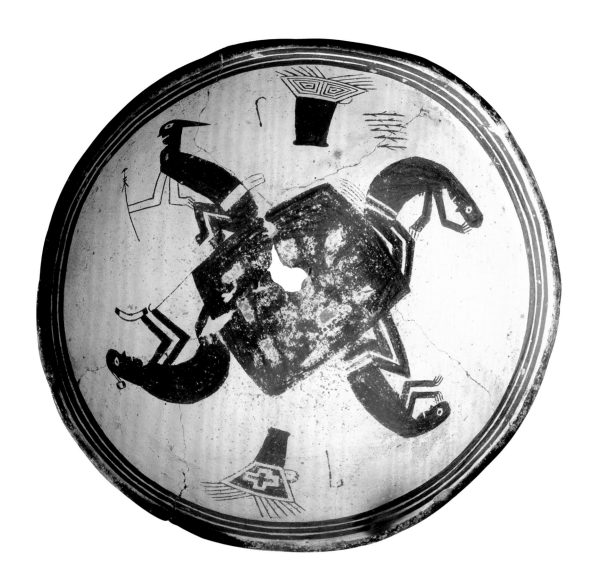

PLATE 13
Mimbres Black-on-white bowl,
Style III, two negatively painted
rabbits
24-15-10/94710
Swarts Ruin, Mimbres Valley
A.D. 1000–1150
Rock-tempered ceramic with
mineral paint
Diameter 21 cm, height 10.5 cm

THIS IS ONE of an ever-increasing number of bowls that we can confi-
dently attribute to a single artist. First recognized by Tony Berlant as the
"Rabbit Master," this painter worked in negative designs; although black
paint was applied to the white-slipped background of the bowl, it
appears as if white paint were used on a black background. The work of
this artist was the catalyst for a hunt for individual artists that still goes on. To identify the work of this artist, a
set of photographs of every known Mimbres bowl depicting rabbits was studied. It turned out that this artist
was distinctive not only for her use of negative design but also for the way she drew rabbit ears, eyes, and tails.
Compare this bowl and bowls 96177 and 96089 (below left and center), probably also by the Rabbit Master,
with bowl 95828 (below right), which illustrates a more typical Mimbres rendering of a rabbit. (Opposite:
T4250.1; below left: T4303.1; center: T4249.1; right:
T4842.1. Hillel S. Burger, photographer.)

Mimbres Black-on-white bowl,
Style III, negatively painted rabbits
27-11-10/96177
Swarts Ruin, Mimbres Valley
A.D. 1000–1150
Rock-tempered ceramic with
mineral paint
Diameter 27 cm, height 13 cm

Mimbres Black-on-white partial bowl,
Style III, negatively painted rabbits
27-11-10/96089
Swarts Ruin, Mimbres Valley
A.D. 1000–1150
Rock-tempered ceramic with
mineral paint
Diameter 29.5 cm, height 21 cm
(if complete)

Mimbres Black-on-white bowl,
Style III, rabbit
26-7-10/95828
Swarts Ruin, Mimbres Valley
A.D. 1000–1150
Rock-tempered ceramic with
mineral paint
Diameter 26 cm, height 9.5 cm

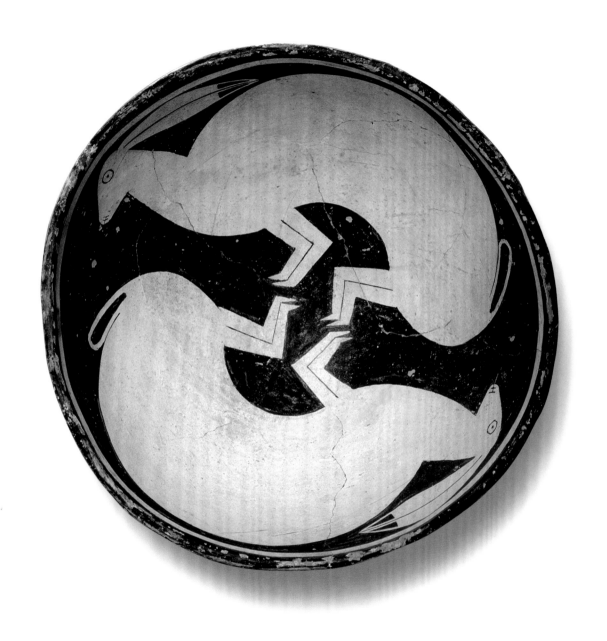

PLATE 14
Mimbres Black-on-white bowl,
Style III, dancing man
24-15-10/94704
Swarts Ruin, Mimbres Valley
A.D. 1000–1150
Rock-tempered ceramic with
mineral paint
Diameter 26.5 cm, height 12 cm

COSTUMING IS FAIRLY commonly depicted on Mimbres pottery. Here, it appears that a man is dancing while wearing a cap with feathers attached to its tip. Most of the costuming shown in Mimbres painting does not cover the face, unlike modern Pueblo katsina masks, which do. It is generally believed that the katsina religion did not develop in the Southwest until after the Mimbres tradition ended, although some precursor elements such as costuming may have been present. (T4235. Hillel S. Burger, photographer.)

A lone Flower Youth is dancing. He dances vigorously to the music of a chorus and the beat of a drum. When the music reaches the high pitch he calls for a while in slow vibrating waves. . . .

This dancer is a Flower Youth. His headdress symbolizes a full blooming of flowers. It might be a parrot's feathers tied together, meaning the same. In a modern Butterfly Dance his position is to lead a long line of dancers single file.
—Fred Kabotie

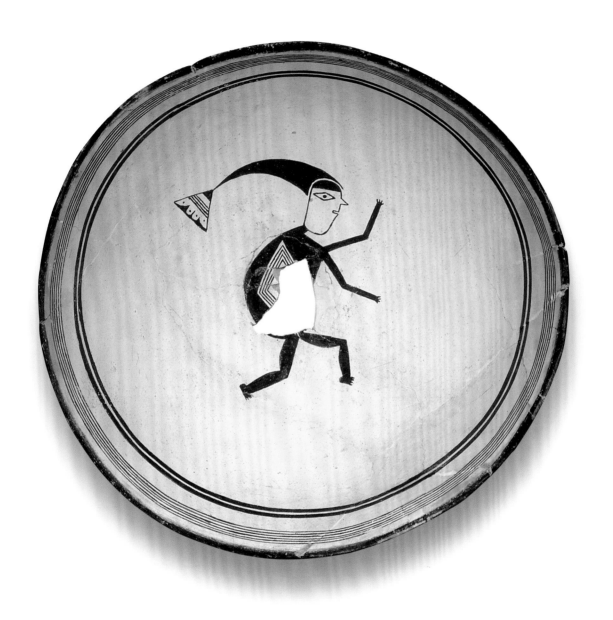

PLATE 15
Mimbres Black-on-white bowl,
Style III, geometric
24-15-10/94722
Swarts Ruin, Mimbres Valley
A.D. 1000–1150
Rock-tempered ceramic with
mineral paint
Diameter 24.3 cm, height 8 cm

THIS IS ONE of another set of bowls almost certainly painted by the same hand. All told, more than a dozen bowls are known that have very similar scroll designs. Four were found at Swarts Ruin, including this one and the three shown below. Subtle differences among these bowls may indicate that the artist's style evolved over time or that some were the work of a daughter or other relative. The image can be perceived as simple scrolls and filler elements applied in black paint (which sometimes fired a chocolate brown), or the field can be perceived in the reverse, so that the white sausagelike elements prevail. This use of negative painting and fat curvilinear elements is reminiscent of the Rabbit Master painting shown in plate 13. Might the Rabbit Master have been responsible for these bowls, too? (Opposite: T4236.1. Hillel S. Burger, photographer.)

Three similar bowls found at the Swarts Ruin, as drawn by Harriet Cosgrove. (From *The Swarts Ruin:* left, pl. 147A; center, pl. 191E; right, pl. 191F.).

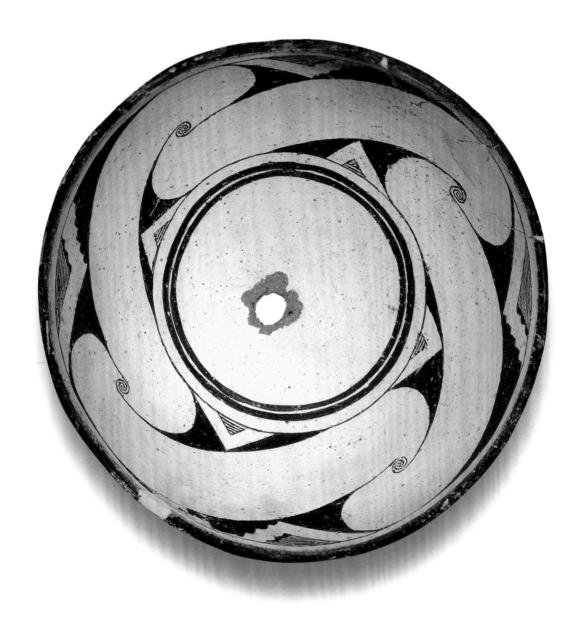

PLATE 16
Mimbres Black-on-white bowl,
Style III, scorpion
25-11-10/94761
Swarts Ruin, Mimbres Valley
A.D. 1000–1150
Rock-tempered ceramic with
mineral paint
Diameter 29.5 cm, height 12 cm

IT IS EASIER TO RECOGNIZE the work of a single artist when looking at the same motif on several different bowls. In the case of this scorpion, the details of the pincers (technically pedipalps), the mouth (chelicerae), and especially the legs are similar to those of the pair of scorpions— perhaps the variety of whip scorpion known as the vinegarroon—on the bowl below. Moreover, the bulbous bodies drawn as geometric elements rather than as bodies with geometric designs inside them, as was the usual custom, and the depiction of three pairs of legs instead of the correct four suggest that these bowls were painted by the same artist. (Opposite: T4194; below: T4234.1. Hillel S. Burger, photographer.)

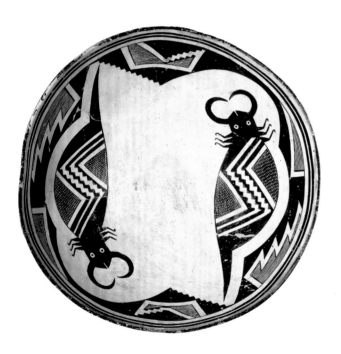

This monstrous looking creature can readily command respect. In addition to his effective weapon for attacking what menaces him, his most outstanding feature is beauty. . . . The whirls and lightning designs are well pronounced on his body. He attacks his enemies with lightning speed, and whirls around them with his tail. —Fred Kabotie

Mimbres Black-on-white bowl, Style III, vinegarroons
24-15-10/94585
Swarts Ruin, Mimbres Valley
A.D. 1000–1150
Rock-tempered ceramic with mineral paint
Diameter 32 cm, height 13.5 cm

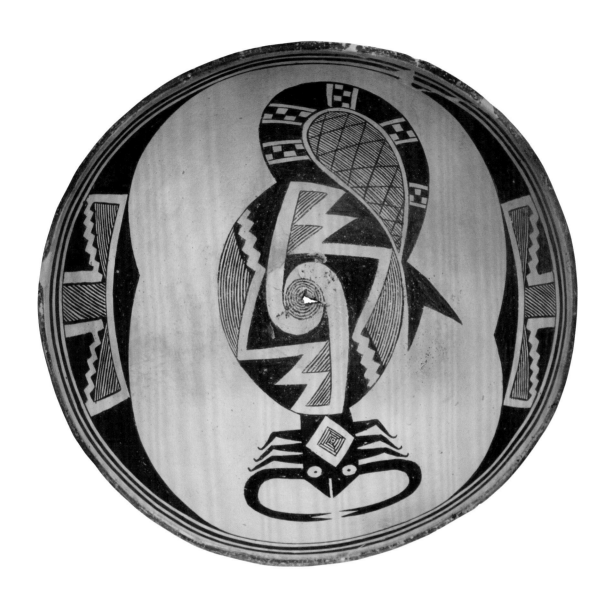

PLATE 17
Mimbres Black-on-white bowl,
Style III, geometric with "eyes"
25-11-10/94794
Swarts Ruin, Mimbres Valley
A.D. 1000–1150
Rock-tempered ceramic with
mineral paint
Diameter 20 cm, height 11 cm

IS THIS A SEA OF EYES peering out at the viewer from the bowl opposite (and below right) or just some diamond and dot designs? If this were the only bowl that played such a visual trick, we might think we were merely reading our own ideas into it, but enough Mimbres bowls have designs that can be perceived in multiple ways that these effects must have been intentional. The bowl below at left is similarly ambiguous, but in this case it is the viewer's shifting from seeing a positive image (birds) to seeing a negative one that creates the ambiguity. (Opposite: T4187; below left: T4297.1; right: T4251.1. Hillel S. Burger, photographer.)

Mimbres Black-on-white bowl, Style III,
geometric with negative birds
27-11-10/96117
Swarts Ruin, Mimbres Valley
A.D. 1000–1150
Rock-tempered ceramic with
mineral paint
Diameter 25.5 cm, height 13.5 cm

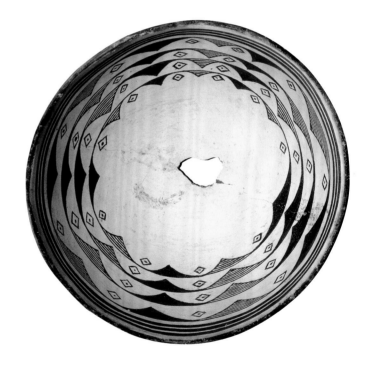

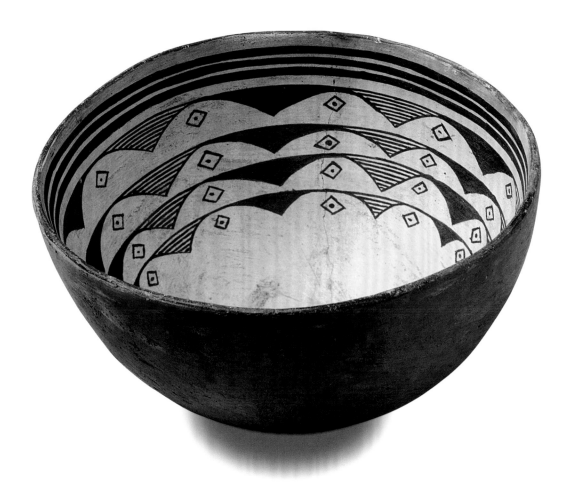

PLATE 18
Mimbres Black-on-white bowl,
Style III, unidentified animal
25-11-10/94825
Swarts Ruin, Mimbres Valley
A.D. 1000—1150
Rock-tempered ceramic with
mineral paint
Diameter 18 cm, height 9.5 cm

WHAT IS IT? That is what everyone asks about the creature represented on this bowl. Because some versions of it appear to have webbed feet (see 96215 below) and because it is sometimes associated with a wavy line that seems to represent water, it might be a tadpole or a frog. Or it might be a fantasy animal rather than an actual one. This animal is always depicted in the negative and fills its space, suggesting that it was the creation of a single artist. Indeed, these characteristics are reminiscent of the painter who drew the negative rabbits shown in plate 11. Such similarity is tantalizing, but an actual association is difficult to demonstrate. (Opposite: T4191, inset: T4190; below left: T4310.1; center: T4224.2; right: T4218. Hillel S. Burger, photographer.)

Mimbres Black-on-white bowl,
Style III, unidentified animal
25-11-10/94793
Swarts Ruin, Mimbres Valley
A.D. 1000—1150
Rock-tempered ceramic with
mineral paint
Diameter 22 cm, height 11 cm

Mimbres Black-on-white bowl,
Style III, unidentified animals
27-11-10/96215
Swarts Ruin, Mimbres Valley
A.D. 1000—1150
Rock-tempered ceramic with
mineral paint
Diameter 15 cm, height 6 cm

Mimbres Black-on-white bowl,
Style III, unidentified animal
25-11-10/94837
Swarts Ruin, Mimbres Valley
A.D. 1000—1150
Rock-tempered ceramic with
mineral paint
Diameter 19 cm, height 8 cm

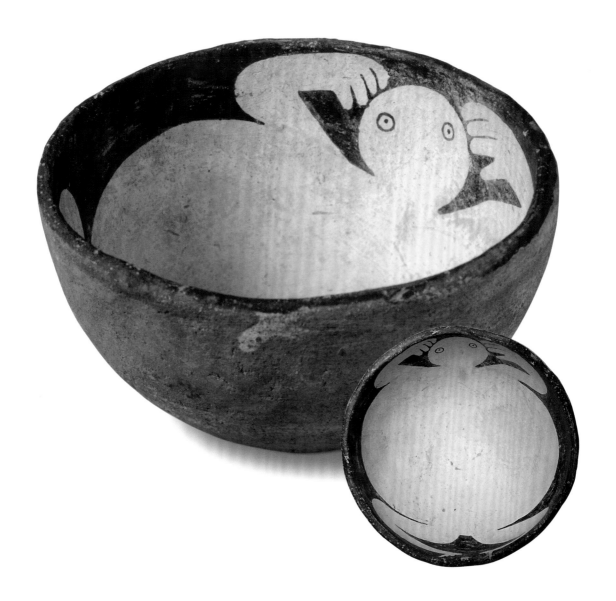

PLATE 19
Mimbres Black-on-white bowl,
Style III, insect blended into
geometric motif
25-11-10/94858
Swarts Ruin, Mimbres Valley
A.D. 1000–1150
Rock-tempered ceramic with
mineral paint
Diameter 26 cm, height 10 cm

ON ONLY A SMALL NUMBER of bowls are figures integrated right into the geometric design. Is this device a tour de force, a deliberate demonstration of how clever the painter could be? Might artists have used this sort of device to give themselves a unique style that Mimbres people would have recognized all over the valley? Or might a number of artists have been trying to integrate figures into geometric designs in friendly competition? In this bowl and the one below, the overall use of space and the way the images are integrated suggest that they were not painted by the same hand. However, one might have been made earlier than the other, and the artist's work could have matured during the interval. (Opposite: T4302.1; below: T4255. Hillel S. Burger, photographer.)

Mimbres Black-on-white bowl, Style III, pronghorn
intertwined with geometric design
27-11-10/96133
Swarts Ruin, Mimbres Valley
A.D. 1000–1150
Rock-tempered ceramic with mineral paint
Diameter 29 cm, height 11.5 cm

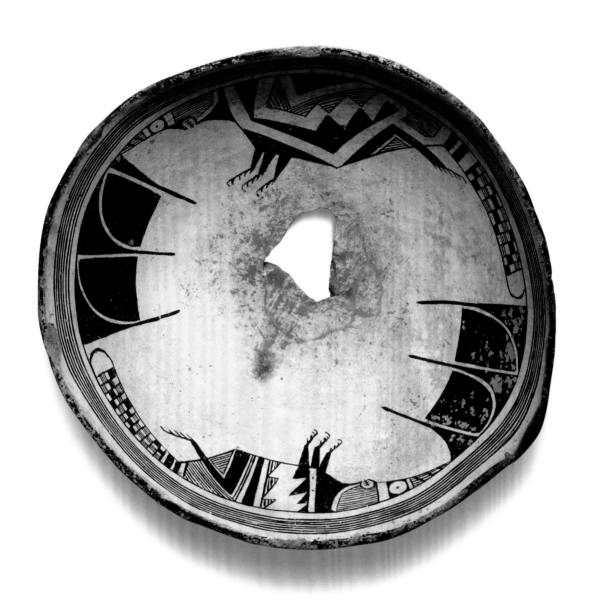

THIS BOWL AND THE ONE below are good examples of the way Mimbres artists took simple elements and turned them into highly complex and striking designs. These design elements were used by many of the other Southwestern peoples who were contemporary with the Mimbres, yet none of them produced designs as strong as those of Mimbres painters. These wonderfully complex, if somewhat busy, geometric bowls have a similar feel, but the bowl opposite is much more finely rendered. Could these have been painted by the same artist, the one below done early in her career and the other at the peak of her skills? Though the similarities are suggestive, it is difficult to make a strong case that they were painted by the same person without additional examples and other lines of evidence. (Opposite: T4177; below: T4839.1. Hillel S. Burger, photographer.)

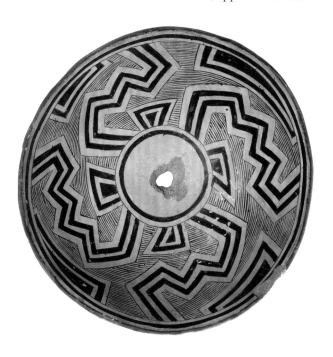

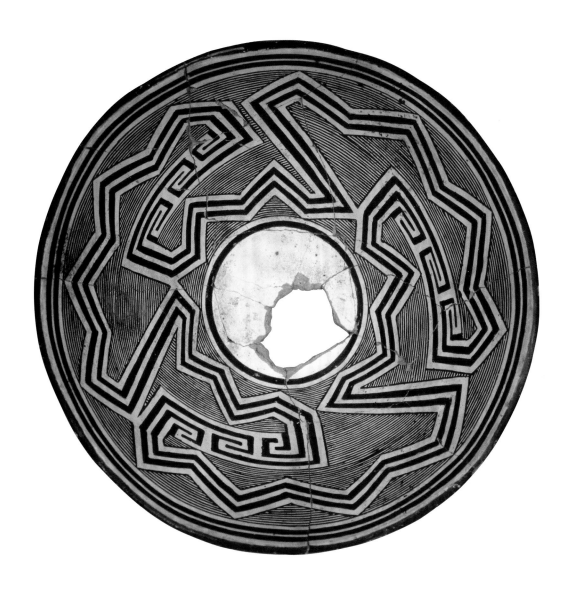

PLATE 21
Mimbres Black-on-white bowl,
Style III, turtle
25-11-10/94917
Swarts Ruin, Mimbres Valley
A.D. 1000–1150
Rock-tempered ceramic with
mineral paint
Diameter 31 cm, height 11 cm

THIS DISTINCTIVE TURTLE, the smaller one shown below, and
another (not pictured here) on a bowl from an unknown site are clearly
by the same hand. The form of the mouth and the attempt to use
geometric elements to simulate the carapace plates on what is probably
a Sonoran mud turtle are seen on none of the sixty or so other Mimbres
bowls that depict turtles. This bowl was the inspiration for the Tony Da painting shown on page 49.
(Opposite: T4293.1; below: T4304.1. Hillel S. Burger, photographer.)

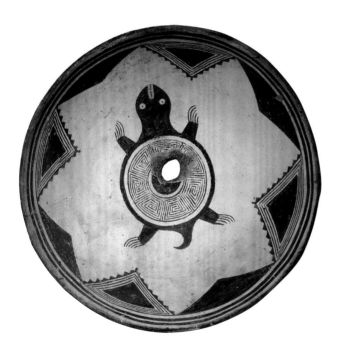

Mimbres Black-on-white bowl, Style III, turtle
24-15-10/94677
Swarts Ruin, Mimbres Valley
A.D. 1000–1150
Rock-tempered ceramic with mineral paint
Diameter 26 cm, height 8.5 cm

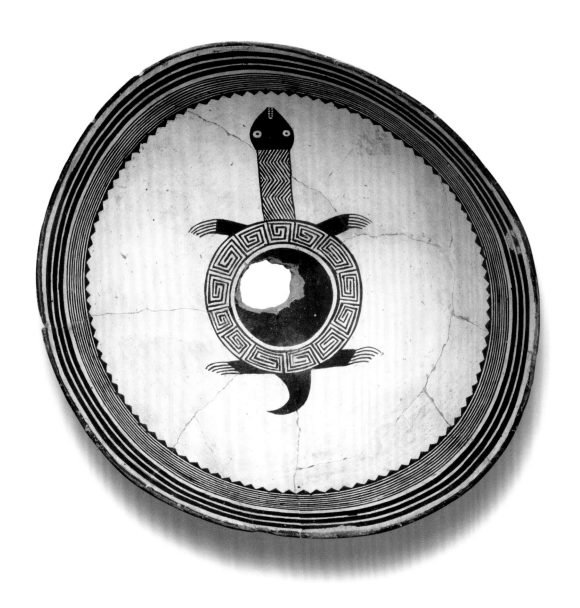

PLATE 22
Mimbres Black-on-white bowl,
Style III, man and bear
26-7-10/95879
Swarts Ruin, Mimbres Valley
A.D. 1000–1150
Rock-tempered ceramic with
mineral paint
Diameter 29.5, height 8 cm

THE MAN ON THIS BOWL wears a typical Puebloan hairdo of the sort seen historically in many villages. The image is therefore an example of both the pan–Southwestern distribution of such traits and their longevity and conservatism. Bear bones are rarely discovered in Mimbres sites, so killing a bear must have been a rare and memorable experience. Of course the bowl may also be read as the bear killing the man. This is because, as in virtually all Mimbres bowls, there is no ground line to show the viewer how to orient the bowl. Rotated one way (opposite), the bear is winning the fight; rotated the other (below right), the man is the victor. (T4296.1. Hillel S. Burger, photographer.)

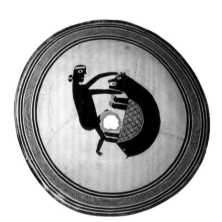
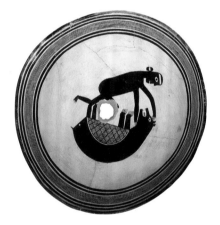

Whenever the bear was killed and brought to the home village of the killer, it was cooked, and the whole village would be invited. Everyone who came to dinner had their faces painted black. This was custom and a formal way of eating a bear dinner. —Fred Kabotie

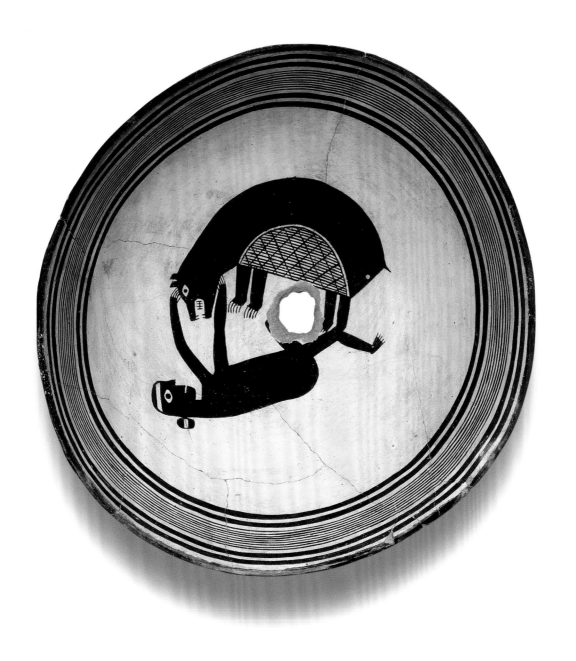

PLATE 23
Mimbres Black-on-white bowl,
Style III, turkey and carnivore
26-7-10/95939
Swarts Ruin, Mimbres Valley
A.D. 1000–1150
Rock-tempered ceramic with
mineral paint
Diameter 18.5 cm, height 8 cm

THIS IS ONE OF THE BOWLS that Fred Kabotie used to identify the "blocking" method of indicating perspective. He suggested that the turkey was not riding on the back of the carnivore but was standing behind it. The ambiguity between the ears and snout (is the carnivore looking up or down?) occurs on a few other bowls as well. We might speculate that this represents a pun playing on some similarity between the words *ear* and *snout* in the unknown language the Mimbres spoke. The white tip and smooth tail of the apparently carnivorous creature suggest it is a feline and not a canine. Only a few carnivores are shown with the bushy tails that we would associate with a coyote or a fox. Either the Mimbreños depicted felines far more commonly than canines or they followed a convention of drawing smooth tails even for canines. (T4215. Hillel S. Burger, photographer.)

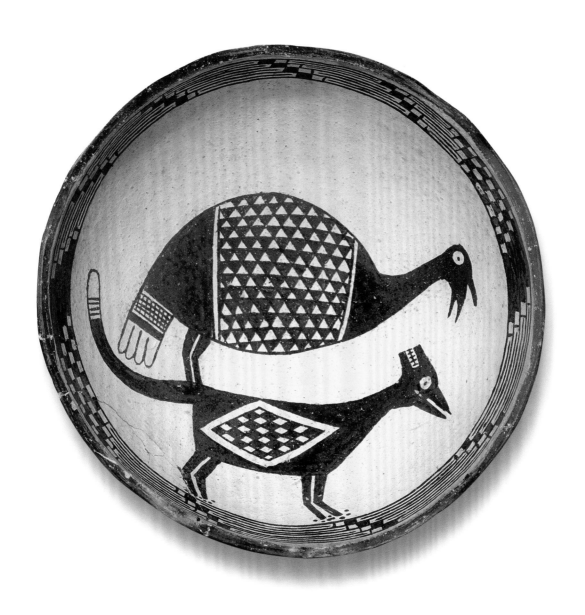

Mimbres Black-on-white bowl,
Style III, geometric
26-7-10/96000.1
NAN Ranch Ruin, Mimbres Valley
A.D. 1000–1150
Rock-tempered ceramic with
mineral paint
Diameter 23 cm, height 10 cm

IS THIS ENTIRELY a geometric design, or do we see a pair of fishtails? Bird tails are painted differently on Mimbres pots, and this image is very much like the tails of what are clearly fish. Enough bowls have been found that show such minimal figurative elements that we can assume this was a deliberate rendering of an animal motif. Were these clever attempts to depict the essence of the animal? This bowl is similar in many ways to the one below. In each bowl, bold rows of triangles radiate from the edge of a larger triangular figure. In such bowls, serrated triangles are an uncommon motif. They are possibly by the same artist, but as in other examples where we have only two similar pots—especially when their designs are geometric—it is difficult to be sure. (Opposite: T4308.1; below: T4233.1. Hillel S. Burger, photographer.)

Mimbres Black-on-white bowl, Style III, geometric
26-7-10/95806
Swarts Ruin, Mimbres Valley
A.D. 1000–1150
Rock-tempered ceramic with mineral paint
Diameter 31 cm, height 11.5 cm

PLATE 25
Mimbres Black-on-white bowl,
Style III, geometric
24-15-10/94645
Swarts Ruin, Mimbres Valley
A.D. 1000–1150
Rock-tempered ceramic with
mineral paint
Diameter 36 cm, height 15 cm

THIS LARGE BOWL with an intricate, almost bewildering geometric design represents the zenith of Mimbres design complexity and shows the artist's willingness to let the color grade from red to black. Mimbres artists made no consistent effort to prevent color gradations during firing, as was done in other parts of the Southwest. Bowls that are believed to have been made by the same artist, however, tend to have consistent color patterns. The work of some artists is all black, and that of others, all rather red; still others made bowls whose coloration grades from red to black. This implies that allowing color variation was intentional on the part of some potters. The similarity of the spacing between elements on the bowl opposite, the bowl illustrated in the frontispiece, and the two seen below, their very large sizes, and the fact that they were contemporaneous (judging from their rim bands) all suggest that they were painted by the same person. (Opposite: T4228.1; left, this page: T4183; right, this page: T4840.1. Hillel S. Burger, photographer.)

Mimbres Black-on-white bowl,
Style III, geometric
25-11-10/94913
Swarts Ruin, Mimbres Valley
A.D. 1000–1150
Rock-tempered ceramic with
mineral paint
Diameter 38 cm, height 15 cm

Mimbres Black-on-white bowl,
Style III, geometric
27-11-10/96263
Swarts Ruin, Mimbres Valley
A.D. 1000–1150
Rock-tempered ceramic with
mineral paint
Diameter 31 cm, height 12.5 cm

Notes

1. Jesse Walter Fewkes, "Archaeology of the Lower Mimbres Valley, New Mexico," *Smithsonian Miscellaneous Collections* 63, no. 10 (1914): 1–53; "Designs on Prehistoric Pottery from the Mimbres Valley, New Mexico," *Smithsonian Miscellaneous Collections* 76, no. 8 (1923): 1–47; "Additional Designs on Prehistoric Pottery from the Mimbres Valley, New Mexico," *Smithsonian Miscellaneous Collections* 76, no. 8 (1924): 1–46. Reprinted together as Fewkes, *The Mimbres: Art and Archaeology* (Albuquerque: Avanyu Publishing, 1989).

2. In some quarters the term *Anasazi* has been replaced by *ancestral Pueblo*. This is based on the erroneous belief that the Navajo term *Anasazi* is pejorative and means "ancient enemy." It does not. It means "ancient others," that is, people who were not Navajo and who preceded the Navajos—an accurate description of reality. Moreover, by implying that Anasazi equals Pueblo, no room is left for a Mogollon (or even Hohokam) component to modern Pueblo culture, yet many Pueblo people believe such a component exists. For these reasons the term *Anasazi* is retained here.

3. Wesley Bradfield, *Cameron Creek Village: A Site in the Mimbres Area in Grant County, New Mexico,* School of American Research Monograph 1 (Santa Fe, NM, 1931); "Jenks in

the Field: University of Minnesota," *El Palacio* 29, nos. 4–10 (1930): 150–151. See also Roger Anyon and Steven A. LeBlanc, *The Galaz Ruin: A Prehistoric Mimbres Village in Southwestern New Mexico* (Albuquerque: University of New Mexico Press, 1984), and Paul H. Nesbitt, *The Ancient Mimbreños: Based on Investigations at the Mattocks Ruin, Mimbres Valley, New Mexico,* Logan Museum Bulletin 4 (Beloit, WI: Beloit College, 1931).

4. C. B. Cosgrove, *Caves of the Upper Gila and Hueco Areas,* Papers of the Peabody Museum of American Archaeology and Ethnology, vol. 24, no. 2 (Cambridge, MA: Harvard University, 1947).

5. A. V. Kidder, H. S. Cosgrove, and C. B. Cosgrove, *The Pendleton Ruin, Hidalgo County, New Mexico,* Carnegie Institution of Washington publication 585, Contributions to American Anthropology and History, vol. 10, no. 50 (Washington, DC, 1949); J. O. Brew, "The First Two Seasons at Awatovi," *American Antiquity* 3, no. 2 (1937): 122–137; Hester Davis, "Awatovi: The Story of an Archaeological Expedition in Northern Arizona, 1935–1939" (Cambridge, MA: Peabody Museum Press, in preparation).

6. For a more complete account of Mimbres culture and history, see, among other sources, Steven A. LeBlanc, *The Mimbres People: Ancient Painters of the American Southwest* (London: Thames and Hudson, 1983).

7. Michael W. Diehl and Steven A. LeBlanc, *Early Pithouse Villages of the Mimbres Valley and Beyond: The McAnally and Thompson Sites in Their Cultural and Ecological Contexts,* Papers of the Peabody Museum of Archaeology and Ethnology 83 (Cambridge, MA: Peabody Museum Press, 2001).

8. Roger Anyon, Patricia A. Gilman, and Steven A. LeBlanc, "A Reevaluation of the Mogollon-Mimbres Archaeological Sequence," *The Kiva* 46, no. 4 (1981): 209–225; Harry A. Shafer, "Ten Years of Mimbres Archaeology," *The Artifact* 28, no. 4 (1990): 1–4; LeBlanc, *Mimbres People;* Paul E. Minnis, *Social Adaptation to Food Stress: A Prehistoric Southwestern Example* (Chicago: University of Chicago Press, 1985).

9. Michael Blake, Steven A. LeBlanc, and Paul E. Minnis, "Changing Settlement and Population in the Mimbres Valley, Southwestern New Mexico," *Journal of Field Archaeology* 13, no. 4 (1986): 439–464; Minnis, *Social Adaptation;* Stephen H. Lekson, "The Surface Archaeology of Southwestern New Mexico," *The Artifact* 30, no. 3 (1992): 1–36.

10. Harry A. Shafer and Harold Drollinger, "Classic Mimbres Adobe-Lined Pits, Plazas, and Courtyards at the NAN Ruin, Grant County, New Mexico," *The Kiva* 63 (1998): 397–399.

11. Roger Anyon and Steven A. LeBlanc, "The Architectural Evolution of Mogollon-Mimbres Communal Structures," *The Kiva* 45 (1980): 253–277; Anyon and LeBlanc, *The Galaz Ruin.*

12. Harry A. Shafer, "Classic Mimbres Architecture and Mortuary Patterning at the NAN Ranch Ruin (LA15049), Southwestern New Mexico," in *Mogollon V,* edited by H. Beckett (Las Cruces, NM: Coas Publishing and Research, 1991), 34–49; Shafer and Drollinger, "Classic Mimbres Adobe-lined Pits."

13. Killed bowls have also been found in nonburial contexts, and some burials contained bowls that were not "killed."

14. Temper constituted less than 10 percent of any one jar, so even a jar that weighed 15 pounds would have contained only 1.5 pounds of temper.

15. Ethnographically, clay is rarely transported farther than a mile or two unless animals or vehicles are used.

16. Patricia A. Gilman, V. Canouts, and R. L. Bishop, "The Production and Distribution of Classic Mimbres Black-on-white Pottery," *American Antiquity* 59 (1994): 695–709; Darrel Creel, Matthew Williams, Hector Neff, and Michael Glascock, "Black Mountain Phase Ceramics and Implications for Manufacture and Exchange Patterns," in *Ceramic Production and Circulation in the Greater Southwest,* edited by D. Glowacki and H. Neff (Los Angeles: Cotsen Institute of Archaeology, University of California, 2002), 37–46.

17. Mark Thompson, "The Evolution and Dissemination of Mimbres Iconography," in *Kachinas in the Pueblo World,* edited by Polly Schaafsma (Albuquerque: University of New Mexico Press, 1994).

18. Steven C. Jett and P. B. Moyle, "The Exotic Origins of Fishes Depicted on Prehistoric Mimbres Pottery from New Mexico," *American Antiquity* 51 (1986): 688–720; Cynthia Ann Bettison, Roland Shook, Randy Jennings, and Dennis Miller, *New Identifications of Naturalistic Motifs on Mimbres Pottery* (Tucson, AZ: SRI Press, 1999).

19. A drawing of a stuffed mud hen associated with clowns is shown, with a discussion, in Alexander M. Stephen, *Hopi Journal,* edited by Elsie Clews Parsons (New York: Columbia University Press, 1936), 501. That this is a visual pun was pointed out to me by Louis Hieb.

20. Unfortunately, this is a looted bowl, known only from a photograph.

21. John D. Beazley, *Greek Vases: Lectures* (Oxford: Clarendon Press, 1989); Christine Morris, "Hands Up for the Individual! The Role of Attribution Studies in Aegean Prehistory,"

Cambridge Archaeological Journal 3, no. 1 (1993): 41–66; Christopher B. Donnan and Donna McClelland, *Moche Fineline Painting: Its Evolution and Its Artists* (Los Angeles: UCLA Fowler Museum of Cultural History, 1999).

22. Tony Berlant, "Mimbres Painting: An Artist's Perspective," in J. J. Brody, Catherine J. Scott, and Steven A. LeBlanc, *Mimbres Pottery: Ancient Art of the American Southwest* (New York: Hudson Hills Press, 1983), 13–20.

23. Other participants in the study were Barbara Fash, David Stuart, Sam Tager, and Stuart Heebner, all of the Peabody Museum, and Tony Berlant.

24. Steven A. LeBlanc and Tony Berlant, "Finding Individual Painters of Hopi Yellow Ware Bowls" (manuscript in preparation).

25. For Mattocks Ruin, roughly 200,000 Mimbres Classic bowl sherds were estimated to have been on the site. It was estimated that each pot had broken into 64 sherds on average, so that altogether at least 3,100 and probably closer to 4,000 bowls had been broken at the site. A similar number probably applies to Swarts Ruin. Yet divided by the 125-year span of the Classic period, this amounts to only 32 bowls broken per year. If each of 100 adults had a bowl, then each broke a bowl about once every three years. The Mattocks Ruin data are from Steven A. LeBlanc, "Who Made the Mimbres Bowls?" in *Mimbres Society,* edited by V. S. Powell-Marti and Patricia A. Gilman (Tucson: University of Arizona Press, in press).

26. LeBlanc and Berlant, "Finding Individual Painters"; LeBlanc, "Who Made the Mimbres Bowls?"; Steven A. LeBlanc and Margo Ellis, "The Individual Artist in Mimbres Culture: Painted Bowl Production and Specialization," poster presentation at the annual meeting of the Society for American Archaeology, 2001.

27. There seems to have been greater continuity in the hallmarks of Mimbres culture in areas peripheral to the Mimbres Valley after 1130, as Margaret C. Nelson considered in *Mimbres during the Twelfth Century: Abandonment, Continuity, and Reorganization* (Tucson: University of Arizona Press, 1999). For the bulk of the Mimbres population, however, the events at the end of the Classic period were dramatic and radical.

28. Tony Berlant tells of seeing Lucy Lewis's copy of the Swarts Ruin report, well used and splattered with clay, when he visited her in the 1960s.

29. All Fred Kabotie quotes are taken from *Designs from the Ancient Mimbreños with a Hopi Interpretation* (San Francisco: Graborn Press, 1949).

Suggested Reading

Anyon, Roger, and Steven A. LeBlanc

1984 *The Galaz Ruin: A Prehistoric Mimbres Village in Southwestern New Mexico.*
 Albuquerque: University of New Mexico Press.

 This report on a Mimbres village contemporary with Swarts Ruin has photographs
 of more than eight hundred Mimbres bowls.

Brody, J. J.

2004 *Mimbres Painted Pottery.* Revised edition. Santa Fe, NM: School of American
 Research Press.

 This newly revised and updated edition of a book originally published in 1977, with
 some 250 illustrations, offers an appreciation of Mimbres pottery from an art and
 art historical perspective.

Brody, J. J., Catherine J. Scott, and Steven A. LeBlanc

1983 *Mimbres Pottery: Ancient Art of the American Southwest.* New York: Hudson Hills Press.

 The catalogue for an exhibit of Mimbres pottery, this book includes essays on Mimbres history, the evolution of the pottery style, and the pottery as art. It is illustrated with more than 125 images of bowls.

Carr, Patricia

1979 *Mimbres Mythology.* Southwestern Studies Monograph 56. El Paso: University of Texas.

 In providing an interpretation of Mimbres figurative imagery, Carr is particularly interested in understanding the images in terms of historic Pueblo oral traditions and ideas. Among other things, she deals with creation myths, Spider Woman, and the twin war gods.

Cosgrove, C. B.

1947 *Caves of the Upper Gila and Hueco Areas.* Papers of the Peabody Museum of American Archaeology and Ethnology, vol. 24, no. 2. Cambridge, MA: Harvard University.

 This report describes the Cosgroves' work in caves in the Mimbres region, which they carried out after their fieldwork at Swarts Ruin.

Cosgrove, H. S., and C. B. Cosgrove

2004 *The Swarts Ruin: A Typical Mimbres Site in Southwestern New Mexico.* A facsimile of the
[1932] first edition. Papers of the Peabody Museum of American Archaeology and Ethnology, vol. 15, no. 1. Cambridge, MA: Harvard University.

 The Cosgroves' book, the first major publication on a Mimbres site, includes more than seven hundred drawings of Mimbres bowls. It was reissued in a facsimile edition in 2004 by the Peabody Museum Press.

Davis, Carolyn O'Bagy

1995 *Treasured Earth: Hattie Cosgrove's Mimbres Archaeology in the American Southwest.* Tucson: Sanpete Publications and Old Pueblo Archaeology Center.

 This popular biography of Hattie Cosgrove focuses on her Mimbres research and is illustrated by hundreds of her Mimbres bowl drawings.

Fewkes, Jesse Walter

1989 *The Mimbres: Art and Archaeology.* Albuquerque: Avanyu Publishing.

This is a reprint of several works by Fewkes on Mimbres pottery that were originally published between 1914 and 1924. The originals were the first publications to depict numerous examples of Mimbres bowls. The reprint edition includes hundreds of drawings of bowls and some photographs.

Kabotie, Fred

1949 *Designs from the Ancient Mimbreños with a Hopi Interpretation.* San Francisco: Graborn Press. Reprinted 1982 by Northland Press, Flagstaff, Arizona.

Hopi artist Fred Kabotie redraws a selection of Mimbres bowls and interprets them poetically from the perspective of Hopi legend, religion, and social behavior.

LeBlanc, Steven A.

1983 *The Mimbres People: Ancient Painters of the American Southwest.* London: Thames and Hudson.

This synthesis of the archaeology of the Mimbres culture as of 1980 emphasizes new information on the ecology, adaptation, and culture change of the Mimbres people.

Minnis, Paul E.

1985 *Social Adaptation to Food Stress: A Prehistoric Southwestern Example.* Chicago: University of Chicago Press.

Minnis analyzes the Mimbres people's effect on their environment and how they induced changes that in turn affected Mimbres society.

Nelson, Margaret C.

1999 *Mimbres during the Twelfth Century: Abandonment, Continuity, and Reorganization.* Tucson: University of Arizona Press.

In a summary of a multiyear research project along the eastern slope of the Black Range, the eastern extremity of the Mimbres region, Nelson explains how the history of these small communities differed from that of the larger villages in the Mimbres Valley.

Shafer, Harry J.

2003 *Mimbres Archaeology at the NAN Ranch Ruin.* Albuquerque: University of New Mexico Press.

A full account of a multiyear field project at a large Mimbres village, this report includes images of all the complete vessels collected from the site and an extended discussion of Mimbres social organization.

Woosley, Anne I., and Allen J. McIntyre

1996 *Mimbres Mogollon Archaeology: Charles C. Di Peso's Excavations at Wind Mountain.* Albuquerque: University of New Mexico Press.

This report on a small Mimbres village on the western edge of the Mimbres region contains a limited number of Mimbres bowl images.